DIGITAL PAINTING
TRICKS & TECHNIQUES:

100 WAYS TO IMPROVE YOUR CG ART

BY GARY TONGE

IMPACT
CINCINNATI, OHIO
impact-books.com

CONTENTS

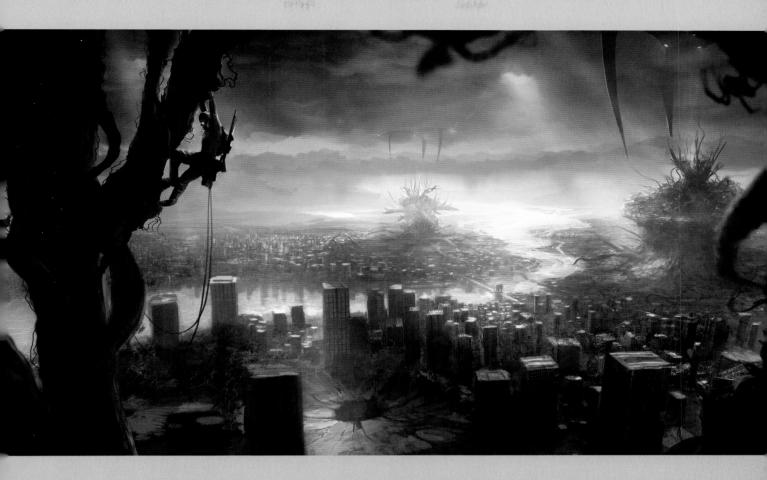

DEDICATION

To the blessings and lights in my life Michelle, Jessica, Catherine and Ella.

And to you Mum, our light up in the stars.

INTRODUCTION

Welcome to *Digital Painting Tricks & Techniques: 100 Ways to Improve Your CG Art*.

I'm Gary Tonge, a professional digital artist working predominantly in the

entertainment software industry. As with my first book, *Bold Visions*, I have written

this book with the intention of helping aspiring and professional artists alike make

the most of their own talents and get more out of the software used to create

computer-generated, or CG, art. Where this book differs from *Bold Visions* is that

I've broken down the instruction into beginner, intermediate and advanced skill

levels, with individual techniques and tips that will hopefully inspire some new

ideas, offer solutions to your art challenges, and help speed up your workflow.

Primarily I use Adobe® Photoshop® to create my art, and it is the focus of this

book. While I often scribble a sketch onto a pad, or model a quick shape in a 3-D

package, I almost always return to Photoshop to finalize my images. Many of the

techniques explored within these pages are quite personal to me, so you will also

get some insight into how I go about painting my art and the tricks I use from time

to time to speed things up, add polish and create great-looking final pieces.

Whether your goals are to update and improve your current skill set, make your

digital-painting hobby more fulfilling, or just see how a professional digital

artist does things, it is my hope that this book will help you find inspiration and

insight into CG art.

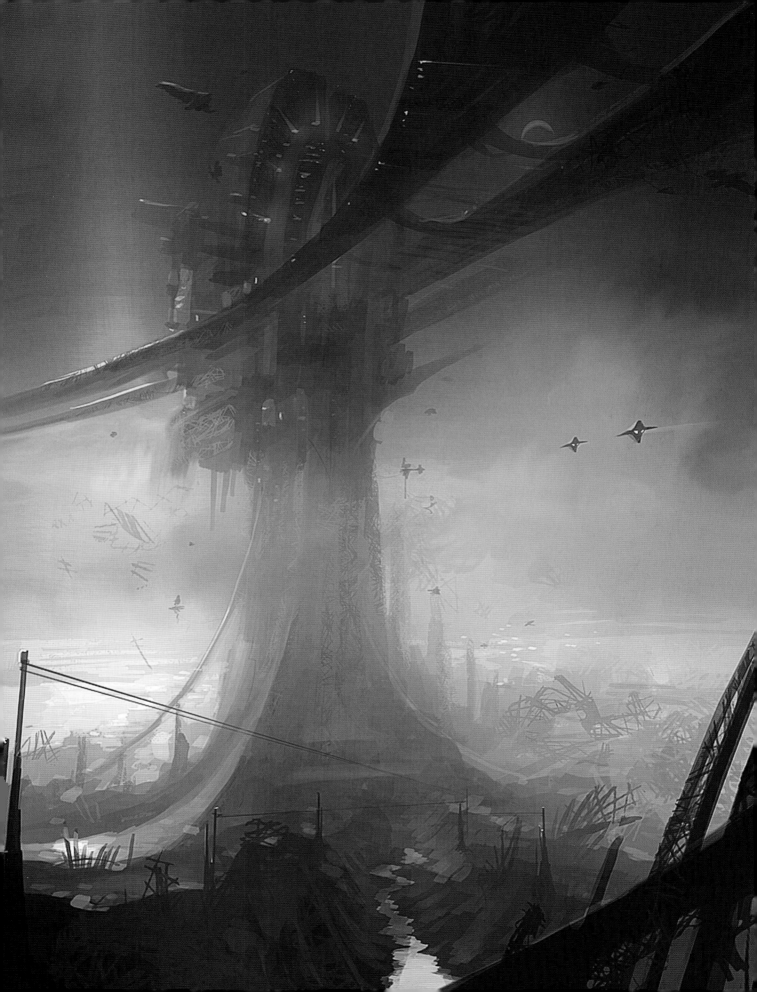

BRUSHES &
BRUSHSTROKES

As you grow as an artist, you'll start to form your own distinctive style. A portion of this no doubt comes from things that influence and inspire you—nature, the work of other artists, and your own imagination. However, one of the most defining elements to any artist's work is the way in which brushstrokes are applied. In this chapter, we'll explore some tips for creating Photoshop brushes and using them effectively in your art.

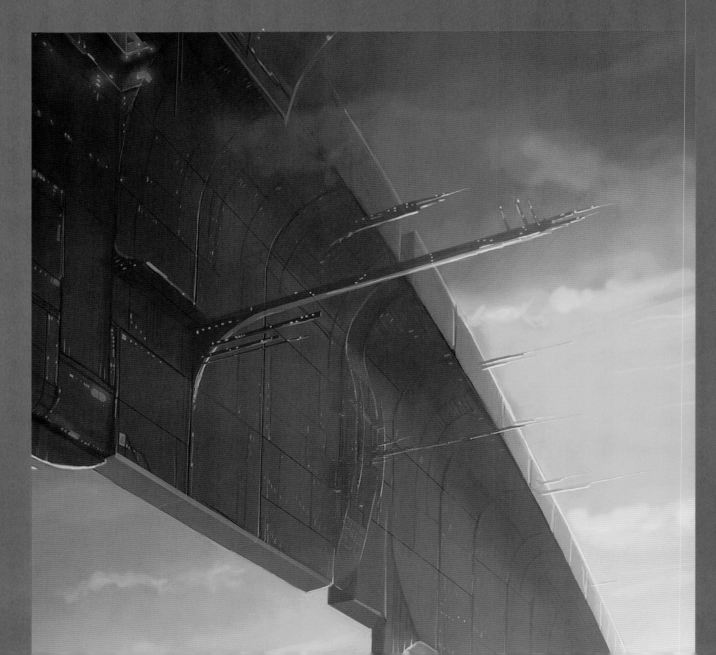

Draw Straight Lines

Straight lines are as simple as it gets when working digitally, and there are a number of good ways to create them. (Please note: The red box and arrow you see below are not part of the original screen shots. I have overlaid them there to help with clarity of instructions.)

Draw Lines With the Line Tool

The most basic method for creating lines is to select the line tool in the toolbox, set the width and opacity of the line you want, then draw lines as you wish.

Hold down the SHIFT button while dragging the mouse or pen to lock the brush in a vertical or horizontal direction—great for creating horizon lines or grids.

To tighten lines up or bridge gaps in a line, click a point on the page with the line tool, hold down SHIFT, then click on another area to create a line between the two points—also known as the SHIFT-Click technique.

Draw Lines With the Brush Tool

A faster, more organic way of creating lines is to hold the SHIFT key and click with the brush tool from one point to the next. These lines were done using a simple round brush with a hard edge.

Important!

If you are serious about progressing as a digital artist, I strongly recommend investing in a tablet, if you have not done so already. Many CG art techniques, including several discussed in this book, are only possible with the use of a tablet.

Get free downloads from Gary Tonge's *Bold Visions* at impact-books.com/digitalpaintingtrickstechniques.

7

Draw Curved Lines

Painting digitally helps make the process of creating accurate curved lines a little easier than it is in traditional painting.

Practice Makes Perfect Curved Lines
If the curves haven't come out exactly as you want them to, keep your fingers on CTRL Z or CMD Z, and undo and redo any erroneous curves until you achieve the desired shape. With practice, drawing flowing curves will become less nerve-racking and the outcome will be much more fluid.

Pencil and Brush Effects With a Tablet

With a tablet, you can make the brush behave in an organic way. Set the *brush shape* and *brush opacity* to *pen pressure*. The harder you press down, the wider and more pronounced the line becomes—just like a pencil or paintbrush.

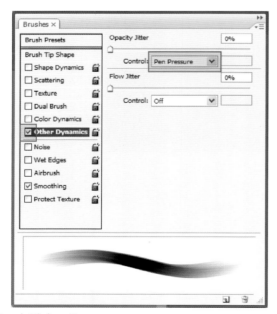

Brush Dialog Menu
I use these settings the most in Photoshop. (Pink boxes are overlays that I placed for clarity of instruction and are not part of the original screen shot.)

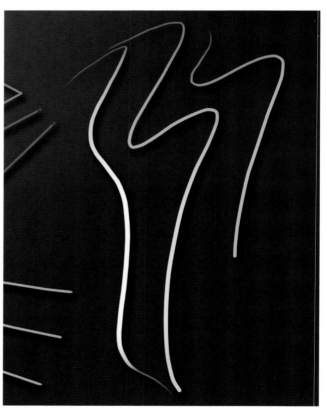

Brush Effects
The squiggly white lines here were created with the brush tool using the pen-pressure setting. This setting will work with any of the painting tools (clone stamp, history brush, smudge, eraser, etc.), but you do need a tablet for this technique.

Intermediate

Stay Loose and Confident

Now that we've looked at some basic brush settings, let's start sketching. Take a look at this loose drawing of a car. I spent only a few minutes on it, using the same principles and settings discussed in the previous section.

Go in Reverse!

If you find the brushstrokes uncomfortable to create smoothly, try temporarily flipping the image. Working in the reverse direction can help.

Be Flexible

Stay loose and flexible with your ideas, including line work. Paint your rough line ideas on one layer, then work up tighter lines on a new layer above. Focus on establishing correct proportions. You can have fun tidying up the lines later.

Create a Sense of Cohesion

A sports car is a perfect demonstration of the importance of brushstroke cohesion. The lines you lay down must give a sense of movement, tension and aggression. Without these, the illusion will rapidly break down.

Brushstrokes Communicate Form

Thick and thin brushstrokes tell the viewer exactly what the shapes are doing. Very few lines are needed to project the shape of this car.

The End Result

The car was lined out, then painted on a separate layer. All the lines aim towards the ground from the back of the car to the front. There is a quick color gradient from light to dark on the background layer. The sweeping brushstrokes used on the background help add a sense of movement to the image.

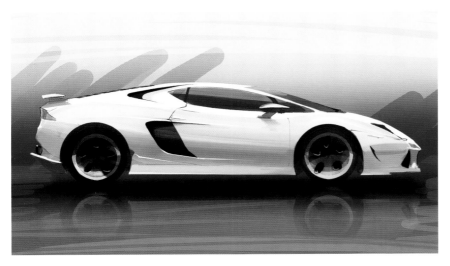

Select and Paint Out

Loose, confident, iterative brushstrokes will always leave behind a legacy of lines you'll want to remove, as well as errors in lines you do wish to keep. The following process is a simple way of cleaning up your lines.

1 COMPLETE THE LINES YOU WANT
Look over your line drawing. In this instance there are several unwanted lines, as well as slightly disjointed lines that you'll want to keep. (I highlighted these in pink for clarity's sake.) Use the SHIFT/click technique discussed earlier to join these lines together. You do not need to be too clinical. The next step will help clean these lines along with the rest.

2 SELECT AND PAINT OUT
Once all the lines are in place, use the polygonal lasso tool to select the areas you don't want. Follow the contours of the lines you want to keep, taking care not to cut too far into them as you select. The selected area (highlighted in pink) is now ready to be painted over with a white brush, if you are working on one layer (as this image illustrates) or erase/delete if it is on a separate layer.

3 CONTINUE ERASING AND PAINTING OUT
Continue selecting and erasing or painting out areas you do not wish to keep. (Each selection here is highlighted in a different color, separated by the primary lines I want to preserve.) Select multiple areas at once by holding down SHIFT when you start a new selection. Photoshop will preserve what you have already selected, allowing you to add to it. Once these areas are selected, erase or paint out as you did in the previous step.

4 THE FINAL RESULT
The end result is much tighter and precise. You don't need to go overboard with this, particularly if you are going to paint up from this point.

Experiment With Brush Settings

This section highlights the brush modes I use most often and explores ways you can find practical use for them in your own art.

The best understanding you can gain about these effects is in the practical application of them. So pull up one of your own images and experiment with the following settings:

- **Mode:** Test various brush modes.

- **Brush Shape:** Try one hard edged and one soft edged.

- **Opacity:** Use different settings to see how each brush mode reacts when stroked across the image.

- **Color:** Experiment with different colors in each mode to see how different modes behave depending on the color selected.

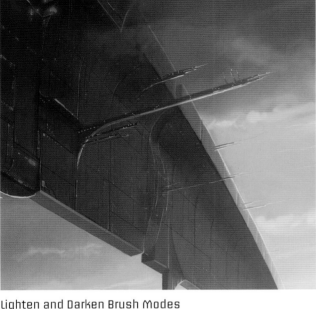

Lighten and Darken Brush Modes

Soft brush shapes and Lighten mode were used to add atmospheric glow. A large soft brush and Darken mode were used to create the diffuse clouds above the structure.

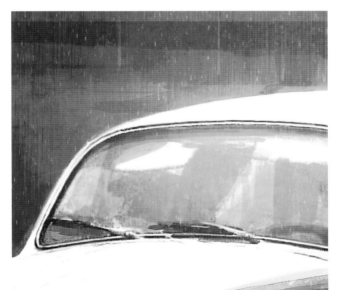

Color Dodge and Linear Dodge Brush Modes

In Color Dodge mode, hard and soft brushes with cyan were used to create glow in the windows. Low-opacity brushstrokes with a soft brush set in Linear mode created glare on the bodywork.

Hard Light and Soft Light Brush Modes

Soft brushes set in Hard Light mode were used to create glows around the stars. Bright colors and large brushes in Soft Light mode created diffuse stellar cloud glows.

Create Textured Brushes

As you start to define your own style of painting, part of this style will come about with the creation of some specific brushes. The following steps were used to create two of my favorite brushes. I use them often, particularly when I create loose and fast sketches of concepts. They are useful for adding texture and organic feeling.

(Please note: The pink boxes in the following images are overlays that I placed for clarity of instruction and are not part of the original screen shots.)

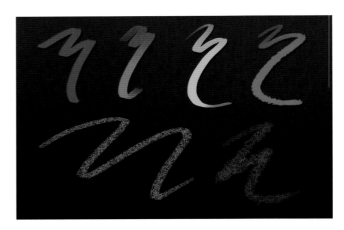

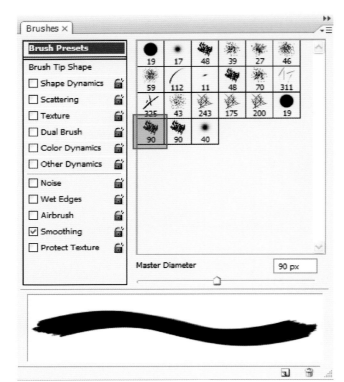

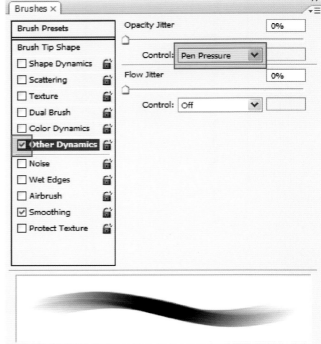

1 START WITH A BASIC BRUSH
Open the Brushes palette and choose one of the basic brushes, Oil Heavy Dry Edges. It is an angled brush with a little nose on it. Set to a 90-pixel diameter. Apart from Smoothing, no other settings should be on at this point. This creates a great basic shape that changes a little depending on the angle of the brushstroke. The red brushstroke was created with this setting.

2 ADD REALISM
Jump over to the Other Dynamics section of the Brushes palette. Set the Opacity Jitter control to Pen Pressure. This adds an organic feel to the brush, changing the opacity of the stroke depending on how hard you press with the pen. The orange brushstroke was created using this setting.

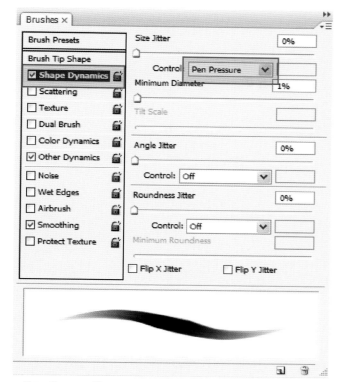

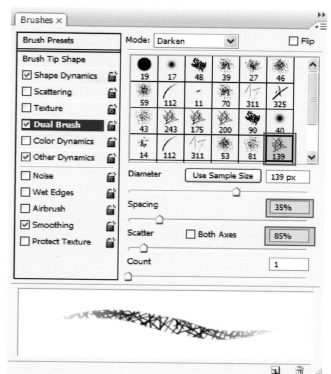

3 SET SHAPE DYNAMICS

Move to the Shape Dynamics section and set the Size Jitter control to Pen Pressure as you did with the opacity in the last step. This produces an angled brush with properties that narrow the brush on pressure as well as lessening the opacity. The yellow brushstroke was created using these settings.

4 GIVE IT SOME RAWNESS

To add more texture and interest to the brush, go to the Dual Brush section. Select a complementary brush pattern to amalgamate with the original shape. (In this case I selected a scattered brush shape.) Then tweak the settings to achieve a nicely scattered look. The settings used here were Spacing and Scatter. The green brushstroke was created with a Spacing setting of 1 percent, and the cyan brushstroke was created with a Spacing setting of 35 percent. The Scatter was the same on both. (I use this brush when I want a rawness to my brushstrokes.)

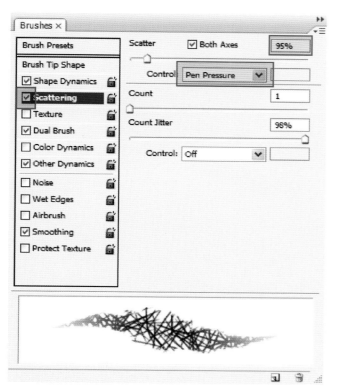

5 ADD A TOUCH OF ROUGHNESS

To break these brush dynamics out of the basic brushstroke, go to the Scattering settings and adjust them to produce an end-scattered feel. The settings used to create the blue brushstroke were Scatter set to Pen Pressure, along with a basic Scatter setting of 95 percent.

Remember to save your custom brush with a new name so that you can use it again!

REFERENCE

A great artist has the ability to interpret reality in a way that is new, beautiful or controversial, exposing hidden messages and depth, and showing people a new way of looking at things. What is paramount to this ability is an understanding of the starting point for all creativity. The initial spark of art comes from our imagination coupled with what we experience, and 99 percent of what we experience occurs in real life. Study and analysis of photographs and other media helps build a foundation for where you could take a piece of art, while keeping reality at its core.

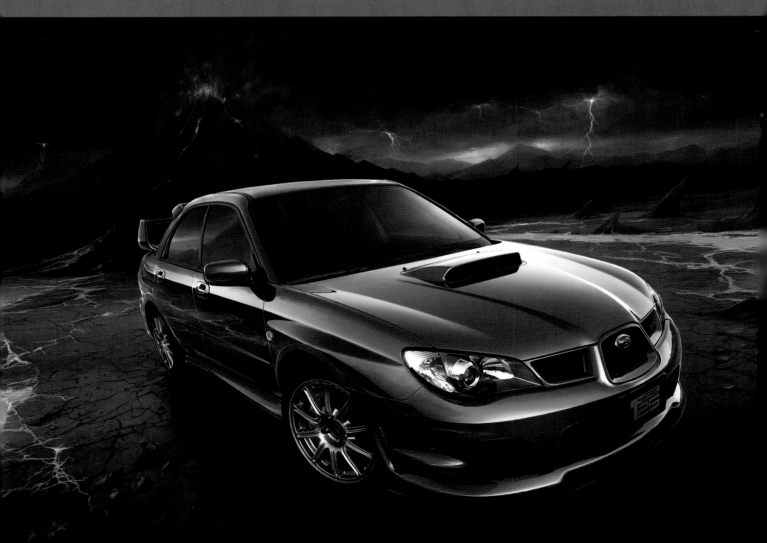

Using Photos as Reference

If you plan to have a career in CG art, creating or sourcing photographic reference will be an important skill to hone. Taking inspiration from photographs is important but so is understanding how to apply that reference to your images. This section shows an example of how I sped up my work flow on a commission in two distinct ways—both using photographic sources.

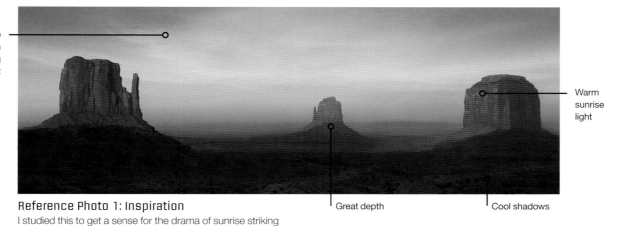

Diffuse sky with radiating light

Warm sunrise light

Great depth

Cool shadows

Reference Photo 1: Inspiration
I studied this to get a sense for the drama of sunrise striking large mountains.

Reference Photo 2: Pasted Image
A photo of the car needed for the ad. The lighting and reflections were wrong, but the angle of the shot was right. I simply placed the car in the final scene and painted over it. Without this image to paint over, the commission would have taken much longer.

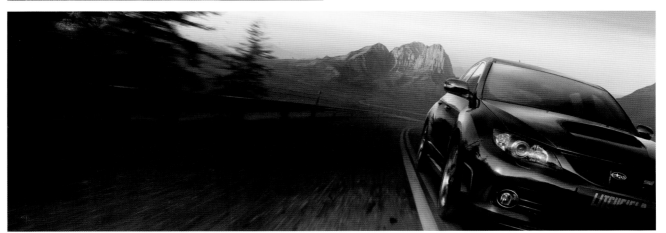

The Final Result
The final piece shows the influence of the first photo on the final image.

Get free downloads from Gary Tonge's *Bold Visions* at impact-books.com/digitalpaintingtrickstechniques.

15

Create an Image Using Photo Reference and Rotoscoping

I was commissioned to create a car ad and, at the time, the only source file I could find for the car was a very low-res image off the Internet. So I used the low-res file for rotoscoping and reference.

When depicting subjects such as cars or people, it is vital to get your proportions right—photo reference is invaluable for this also.

Rotoscoping

Rotoscoping is an old term used to indicate bringing a real-world source (film, photograph or drawing) into a piece of 2-D or 3-D work so that you can trace and reference from it. It is also often referred to as reference layers.

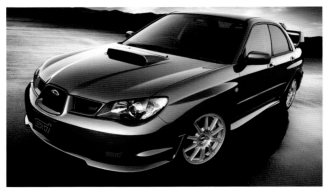

1 START WITH THE ORIGINAL IMAGE
A shot of the MY06 Subaru Impreza STI. The shot is not great quality, but it was sufficient enough for what I needed.

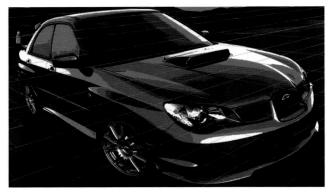

2 FLIP, DESATURATE AND ADD PERSPECTIVE LINES
Flip the image so the car points from left to right. Apply a couple of color passes, Desaturate and Brightness, and contrast to achieve a sharp representation of the photo. Add perspective lines on a new layer using the car as your guide.

(I added the color passes with the intention of defining the strong lines and shading of the car. These alterations gave it a great sense of shape.)

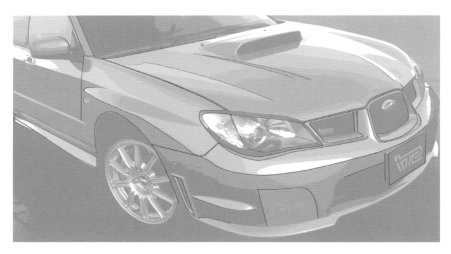

3 CREATE LINES
Add two layers above the photo. Set the bottom one to 50 percent opacity and fill it with full white. Then use the line and brush tools to create these lines on the top layer.

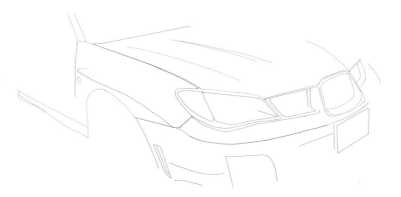

4 CHECK FORM LINES

Change the opacity of the white-fill layer to see how the car is forming up in lines. (The white-fill layer should be placed above the rotoscoped reference but beneath the line layer.) Establish enough lines to form the car, but don't overdo it and end up with a line drawing.

Before

After

5 OVERPAINT COMPLEX DETAILS

Refine lines and details, like the lights. Augment the lights, adding detail and lighting, to represent the reflections in the rest of the image, such as the red tones from the lava.

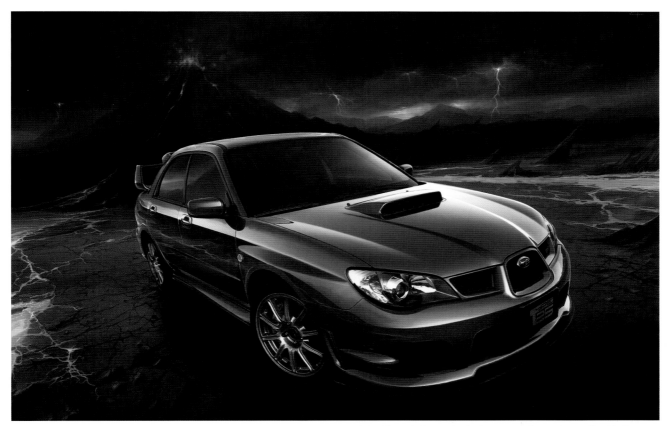

6 THE FINAL IMAGE

The final image wasn't created in six simple steps, but the process explained here is the underpinning to creating an image like this from raw photographic materials.

Bring Diverse Mediums Together

To give you the best possible understanding of how to amalgamate multiple source materials into one cohesive image, let's break down a completed image step-by-step so you can get an idea of how it came to completion.

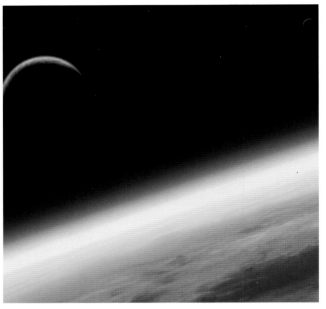

1 START WITH YOUR PHOTO REFERENCE

Choose reference photos with a good a mixture of angles and interesting perspectives. The foundation for this piece is the planetary backdrop photo. It is not much more than a curved line with gradients, but this is more than enough for setting out a composition.

The lighting reference is a spectacular sunset with the sun striking the underside of the clouds. It makes it easy to imagine you're viewing these clouds from above—ideal for an orbit-based atmosphere.

2 CREATE THE BACKGROUND

Create the final sky background by using the original color tones from the simple color-washed planet image and paint over that with ideas from the lighting reference photo. Paint in distant stars and a moon ensure depth and drama.

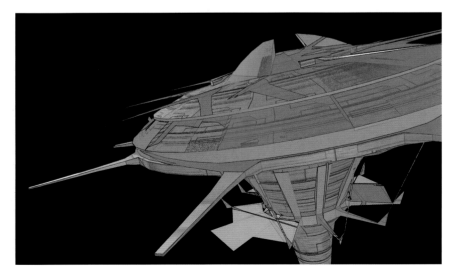

3 STUDY REAL-LIFE REFERENCE

Use simple virtual models to help position elements into a scene. (When working on complex images, an understanding of 3-D models can be an invaluable asset to speeding up your work flow.) In this case much of the line detail was created using the modeling package for this spaceport. This will make things a lot easier when it's time to finalize perspective and positions.

4 PAINT OVER AND RETOUCH
Paint over the image to add texture, lighting and life. Retouch as needed.

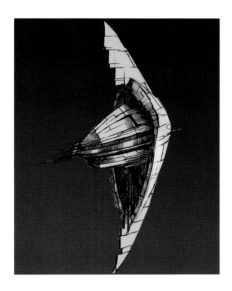

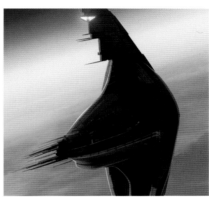

5 APPLY OTHER MEDIUMS
Pencil-sourced images can also be scanned in and painted over to produce the result you see here. It is pretty much the same processes to adapt both the rendered spaceport and the pencil-sourced craft. What is important is the cohesion of the final image.

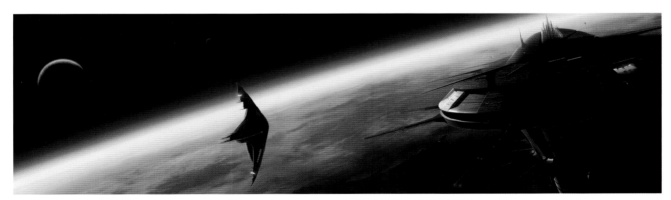

6 THE FINAL RESULT
This piece looks like it was created 100 percent in the same medium. Pencil, scanner, 3-D model rendering, photographs and digital painting all come together as one.

Matte Painting and Merging Photos

Matte painting is a big business. Almost every sci-fi or fantasy movie or television show you see today uses many digital matte plates to give depth and drama to large scenes. Computer games also use mattes to add detail that would be too slow or difficult to process in real-time. The key to a successful matte is great integration. Here we have a photo-manipulation image I created as a starting point to show how matte painting and photo merging are done.

1 START WITH THE ORIGINAL IMAGE
Study this photographic-quality image created from multiple sources. Pay attention to things like the lighting, which will determine how you paint or composite new features into the image. Note how some bright direct light strikes the rock towers, but a large amount of the landscape is lit by diffuse light from the wispy clouded sky. This is a very important detail to keep in mind.

2 ADD SOMETHING ALIEN
Add more contrast and brightness in the next layer. Create the snaking rail using the polygonal lasso tool. Don't worry about the selection incurring over the rock towers. Color-wash the rail shape into place and then simply erase the areas where you want it to go behind existing elements. The key is using the color picker to select good colors for the rail. Think about where the rail is in relation to your existing elements. Harmonize the colors you use for the rail shape with the colors present in the photo at the corresponding distance.

3 ADD THE SPACEPORTS

Make a new layer behind the one you made for the rail but on top of the original photo. Hide the rail layer for now. Use the color picker to select tones that are similar to the color in the distance, and paint in some rough shapes on the new layer. These enormous structures are very far away, so diffuse them greatly with the colors present in the photo. Play with different shapes for the spaceports while you have them on a separate layer.

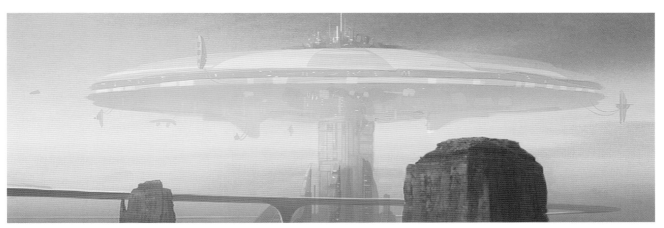

4 ADD DETAILS

Unhide the rail layer. Once you have the basic elements in place, add details to bring out the spaceports. Dapple lights onto the structures, according to how they might work for real (do not just put them anywhere). Add areas of hard lines to the structure, just enough to let the viewers' eyes imagine the rest. Add small, docked spacecraft as a way of showing scale. These nuances of detail are enough to bring the whole image together, so don't overdo it.

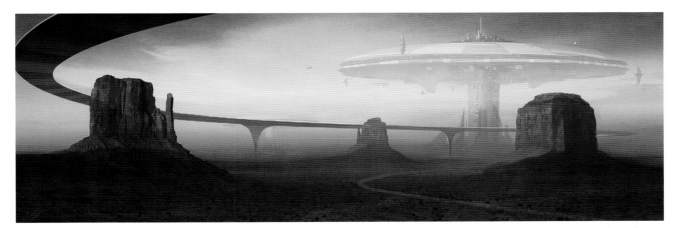

5 SAVE, FLATTEN AND ADD FINAL TOUCHES

Save the file out-layered (as a layered PSD) and then again with a new name. Flatten the image and add some last touches of detail, such as more lights using the color dodge tool. Run a couple of subtle color passes of the image to help bring it all together. There you have it, an augmented photo with some enormous spaceports!

Adapt Photos for Use in Illustrations

Manipulating photos digitally for either reference or part of an image can be a lot of fun. Here is a very simple step-by-step process showing how to use a free photograph from the Internet and employ it as the foundation for a quick digital painting.

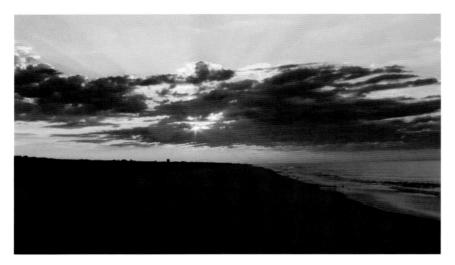

1 START WITH THE ORIGINAL PHOTO

Here is the original photo, courtesy of publicdomainpictures.net. There is nothing particularly amazing about the photo, but it does have some nice cloud formations with the sun peeking through them. Imagine you want to use those clouds as a backdrop to an alien landscape.

2 CROP THE IMAGE AND ADJUST THE COLOR

Start by cropping the ground out of the image. Change the canvas size to add an area of space back in at the bottom of the image. Select just the bottom part of the sky and stretch it to fill the new area. Once this is done, you can begin playing with the colors. (There is always scope for more contrast and color.)

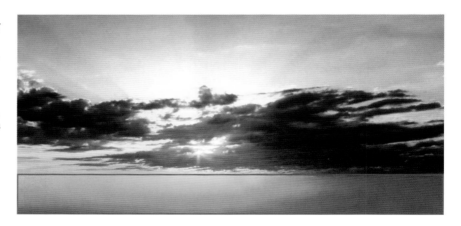

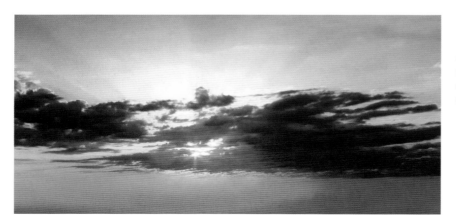

3 CONTINUE ADJUSTING COLOR

This will be an alien skyline, so tweak the color towards an off-world look by adding red and cyan. You can also tweak the brightness and contrast to stop the brighter colors from overexposing.

4 ADD A ROUGH PAINTING

When you are happy with the sky, add another layer and start painting away. Add some simple shapes in the distance to imply a city. Focus on detailing the larger towers, making their tops push through the clouds. Paint a very loose ground and mountain range, taking just enough time to roughly match the colors and tones to the photographic foundation.

5 STRETCH THE CANVAS

Stretch the framed areas of the canvas. Doing so changes the composition somewhat. Add a bit of space to the canvas on the left-hand side, select the area you want to stretch and stretch it to fill the new border of the image. (The red frame was placed for clarity and is not part of the original screen shot.)

The Anchor grid area denotes where you'll want the root of your alterations to come from. (I selected the right-middle area of the piece as the root.) Any additional or removed areas on the canvas would occur to the left, not the right, above and below the current canvas size.

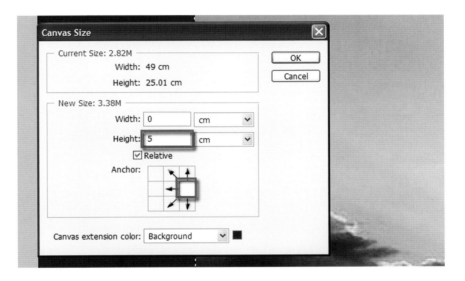

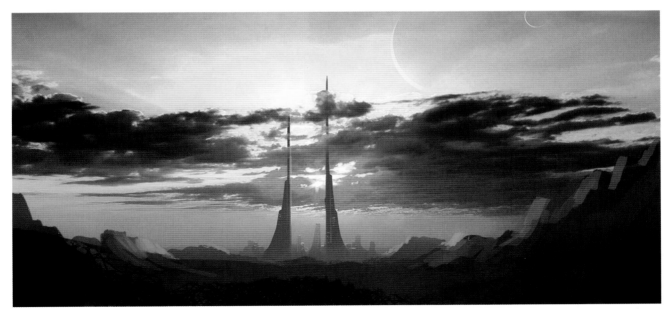

6 MAKE FINAL TWEAKS

Flatten the image and play around a little. Use the Color Dodge tool to add a couple of glows around the areas of the cloud nearest the sun. This will help draw the eye of the viewer there. Add a couple of moons in the sky to further the alien feel. Tweak the colors with Color Balance one last time to solidify everything.

Get free downloads from Gary Tonge's *Bold Visions* at impact-books.com/digitalpaintingtrickstechniques.

23

COLOR

Color is very important to the creative process. Understanding color is paramount to being able to dissect reference materials or inspirational vistas or subjects. Understanding how colors behave within a piece or environment gives you an enormous advantage when it comes to creating your own visions.

We can all look at a piece of art and know how we feel about the use of color, and whether we like it or not. But understanding why colors can make you feel a certain way (hot, cold, scared, angry, hopeful) is the key to being able to project much more emotion into the pictures you create. In this chapter we will talk about how to break down the ways to deal with color and how it augments your ability to create emotive imagery.

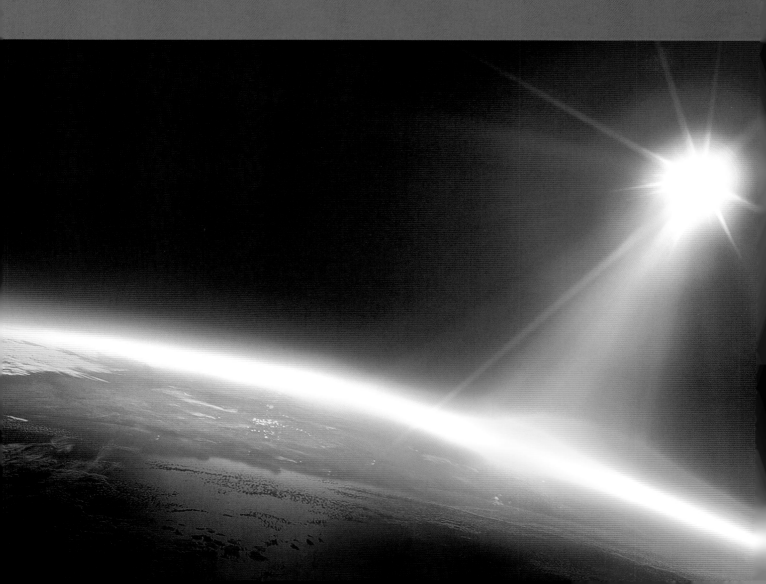

Beginner

The Color Chart

A color chart (sometimes called a color wheel) is an excellent way of visualizing the color frequencies visible to the naked eye, and a powerful tool for understanding how colors can work together in a piece.

Complementary Palettes

When opposite color sets are mixed together, the classic complementary palette, a selection of warm tones offset by cooler tones or vice versa, is formed.

Color Chart

The vertical or "0°" position is taken up by full red. 120° is full green, and 240° is full blue. These three channels are used by computers to create color mixtures digitally, so they are referred to as the primary colors in digital art. Notice the progression of colors from warm into cool. Understanding how colors progress from one to another across the chart is a good foundation for working with color in your paintings.

Choosing Colors

The top right of the color chart has a spread of colors from red to yellow. They form the classic warm palette—colors you might see at sunset, in a volcano, explosion or warm vista.

The colors at the bottom left of the wheel form the classic cool palette and are the cornerstone of a cooler or more tranquil image.

Analyzing Color in a Piece

This piece uses a classic complementary palette. The various color tones across the image affect viewers' understanding of the composition, lighting, scale, drama, movement and depth. The cooler blue/steel tones create a feeling of technology and scale, while the redder tones counter with a feeling of visceral natural heat.

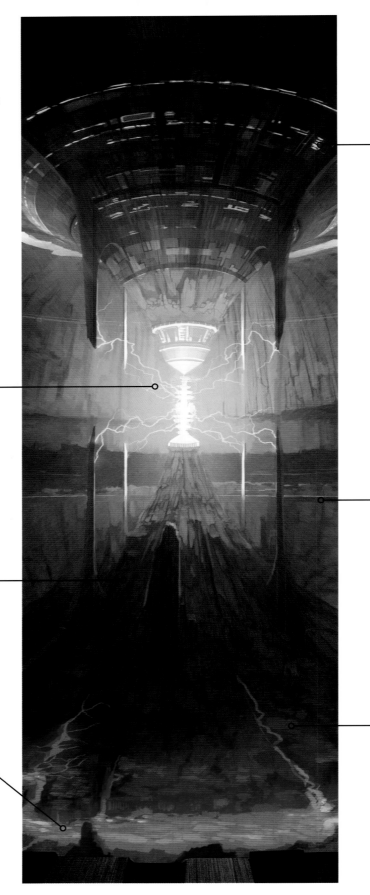

Daylight
Muted (softer) saturation and a bright gray-green-blue color give the impression that it's daylight in the cavern, but is probably overcast outside.

Technology
The mixture of green, blue and red tones helps give a man-made feeling to the lights dotting this device. Using too many warmer colors here would have undermined the difference between the natural lava flow and the technology which is tapping power from it.

Man-Made Heat
The lighting at the center of the geothermal device is very hot, but there is danger that the viewer will see the blue tones as cold. This is countered with very bright tones towards the turquoise/green end of the color wheel (which edge towards warm).

Cooler Rocks
The rocks get progressively cooler as they move farther away from the magma flow. The center light source pours blue light onto the mid- to higher-level rocks inside the cavern.

Cold Metals
The metallic walkway is more muted in color, almost gray looking. This gives an impression that the material is not only tough, but cool and able to cope in the environment it is placed.

Hot Rock
A diffuse brown/orange glow was used for the rocks close to the perimeter of the hot lava to convey the feeling that these rocks are hot, maybe on the cusp of melting.

Nature's Heat
The bottom of the piece is dominated by the glowing and simmering lava flow. The colors used to designate the lava give the sense that this is a naturally caused, fire-like heat.

Intermediate

Balancing Color Palettes

Analyzing the way color works in a subject, photograph or painting is very important. As you learn to see what the color is doing, you will start to build up your own artistic expertise and create similarly cohesive uses of color.

Take a look at some artwork you like and break down why it works for you. As an example, let's study a crop of one of my pieces and break down how and why the colors used work well together.

Bright Colors Come Together
The meshing of bright colors is very important. Notice the blue of the wall when sunlit with elements of yellow warmth compared to its look in shadow, where the blues are tempered to a cooler and slightly less saturated tone.

Cooler Shadows
Where the sunlight has a little warmth, the shadows are nudged to the cooler end of the spectrum, just enough to give a comparative sense of the coolness of the shade.

Colored Light
The red and green hanging fabrics work in this scene because you can see evidence of their material affecting the other materials around them—such as the tinted shadows which really sew these elements into the scene.

Sense of Warmth
The brushstokes are loose, but a great deal of care was taken in pinning down the slightly rose-red sunlight color that sits nicely between the other vivacious colors in the scene.

Reducing Color Saturation
Knowing when to temper the use of color is just as important as adding color to a piece. The colors of the blue buildings are still there in the shadows, but they are grayed and cooled dramatically in contrast to the vivacious sunlight areas.

Speed Painting
This image is a rough and loose portrayal using some color and architectural ideas from Havana, Cuba. The color range used in this piece is actually pretty wide with a good mixture of yellows, blues, reds and greens.

Handling Difficult Colors

Some colors naturally work together and look great when used in a piece alongside each other. The Geo Thermal piece is a great example of this—the reds and oranges give the expression of heat alongside the cooler blues and grays. However, not all complementary palettes work as well as that one. Here we have a hue-shifted version of the reactor shot, shifted clockwise 90°. While this might seem like a simple demonstration, it is a highly effective way of illustrating how certain color spaces using the complementary system are much harder to express than others.

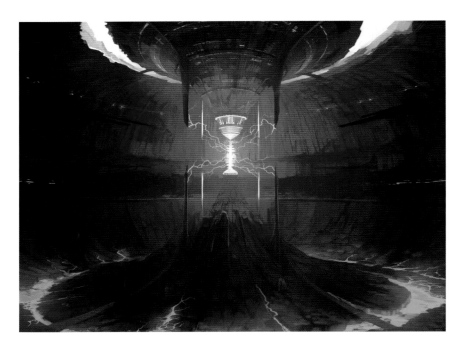

90º Clockwise Offset Palette

There are some elements here that still work very well, most notably the purple glowing electrically charged center of the piece. The diversity and cohesion between these colors does not work nearly as well though. Remember, this is still a complementary palette; all that's been done is a hue shift.

90º Clockwise Offset Palette—Fixed

Adding a wash of blue over the piece helps fix things a bit. The subtle addition of another color seems to make it work better. Effectively, the blue is building a "bridge" of color between the vivacious greens and purples. It's no coincidence that the blue shade is in the middle of these two colors on the color wheel. While the image still looks much better in its original colors, there is no doubt that linking these more aggressive complementary colors with a middling color has helped bring the piece together.

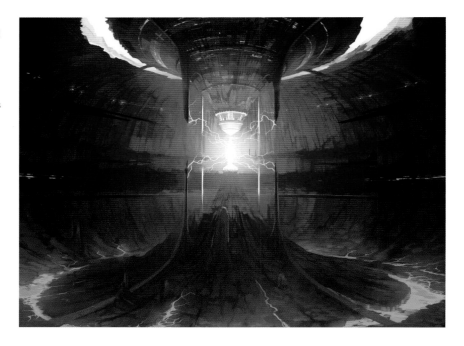

Experiment With Color Mixes

The best way to find new and exciting color schemes is to quickly play around with color swatches and apply them to very loose sketches or image ideas. This technique is a very good way of learning how to amalgamate colors together quickly and effectively, without having to go into the process of painting up a full piece. Here we have three sets of swatches with image crops beside them. Let's break these down and explore how the diverse types of green in the swatches are used in each piece.

Dark Tones
A rough color swatch of some warm oranges and yellows that are complemented by some cooler and less saturated green tones. The greens have a slightly musty sense to them along with their cooler feel. They feel very much in shadow against the bright oranges.

Light Tones
Greens are used again, but they're slightly bluer and more saturated. Although green is considered a cooler color, the overall light and heat in this piece is supplied by a green light. When using a cooler color this way, be careful not to have too many other colors of equal strength. Notice the reds in the scene appear muted and cooled next to the green light. Normally, the function of these colors would be reversed.

Dark and Light Tones
There are not many colors more diametrically opposed to each other than bright green and bright purple, yet they work so well together because the balance is just right. The little area of yellow not only helps establish the middle of the flower, but also builds a bridge between the green and purple. Beware of using colors this aggressively in your own work though. It can be challenging to integrate such different colors effectively.

Try a Narrow Color Range

As you learn more about how to get the best out of colors, you'll find that sometimes less can be more. Here we have three versions of the same image, each tweaked slightly using the color filter settings of Hue, Saturation and Brightness, Color Balance, and Curves. The resulting color-graded images feel completely different from the original piece.

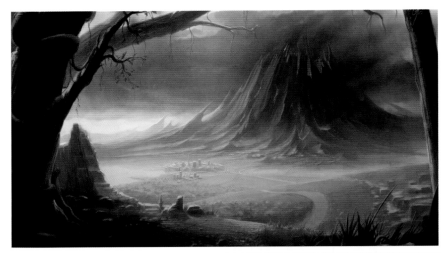

The Original Piece

I used this piece as a starting point because of the wide color range employed to accomplish this landscape. The reason for the wide color range was purely conceptual—the brief was for a very bright and vivid vista, giving the impression of a quaint looking land being consumed by an acrid volcano. However, there is more than one way to project this vision.

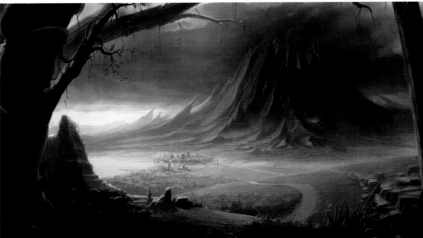

Autumnal Color Grading

With some fairly minor tweaking in the color filters, the image now has a more controlled palette. The saturation and contrast levels are still there, but the majority of the colors are at the warm end of the spectrum, giving the piece an autumnal and warm feel. The color palette is reduced, but the image is still tight and interesting.

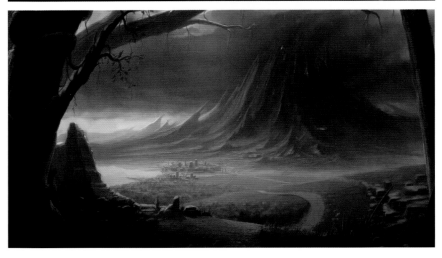

Cool Color Grading

The width of colors is narrowed further here to give the piece a cold feeling. I did not allow the color grading to drag down the tones of the distant volcano too much, and the slight diffusion gives the impression of a misty, damp landscape without having to paint a drop of water. The color range is not wide at all and focuses on just greens and blues—all low saturation. The volcano doesn't stand out as much as before, but still has an imposing presence.

Color Control and Cohesion

The idea of creating a multicolored and wonderfully vivid image can be an attractive proposition, but with every additional color you add, you must think about why the colors are in the picture and how they affect elements around them in the scene. The simple rule I follow is, "Use as much color as you like, but be sure it makes sense." Let's break down some color components so you can see how I make my color choices.

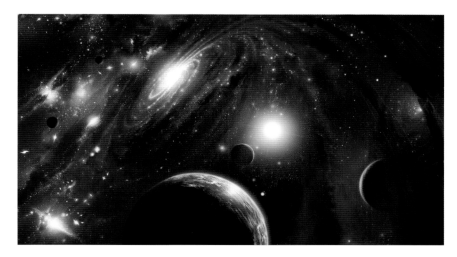

Set a Foundation Color

Color makes sense when it influences what is around it. Attention to detail is paramount. Because of the complex subject matter, I chose a specific foundation color of blue for this image. The glowing yellow sun subtly radiates a warm light towards the worlds lit by it. The galaxy has a combined glow that overcomes the blue foundation at its center. These colors used were not easy to choose or integrate. I thought much about how to add the elements of color and where to place them to add depth and movement to the image. When working with lots of color, it's also important to know when to stop. Keep your color use believable.

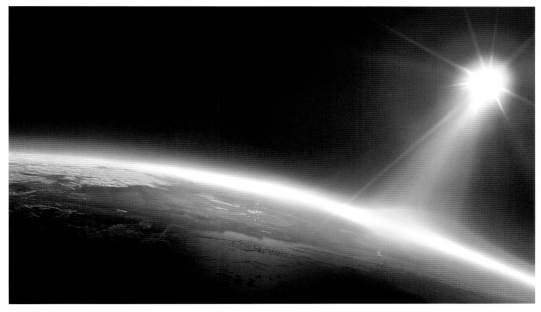

Link Diverse Colors

These colors are as strong as you can get without overloading the saturation levels. A complicated part of this piece was giving the impression of a light source that changed frequency (color) across the width of the image. I used a variant of white as the anchor point for all the colors meeting in the distance. Bringing colors together at the horizon is an excellent way to illustrate how diverse colors are linked. The warmer sector of the color spectrum was used on the area closest to the sun. As the hues progressively change from left to right, they move towards the cooler end of the spectrum, giving a rim-lit and sunrise feel to the area.

Pushing Color Theory Boundaries

There are infinitely diverse ways to go about any type of treatment for a new illustration. To demonstrate just a handful of some of the many directions you could take, I sliced up an image to show different color ideas for the same vision. Each one gives the image a different feel while keeping a high level of cohesion and believability in the scene.

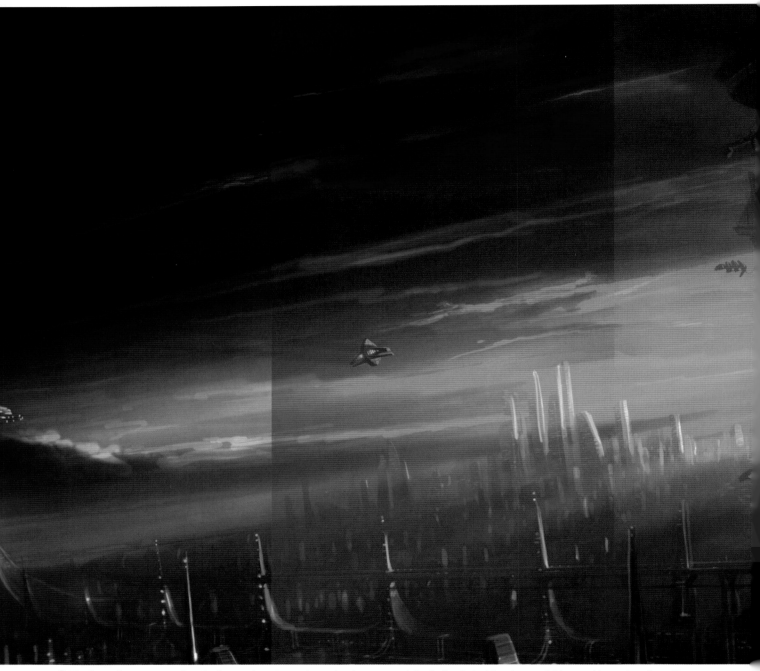

1 The first color treatment gives the impression of a predawn sleeping city. The cooler tones give a tranquil and slumbering sensation to the piece. The lack of any air traffic helps augment this, but the effect of night is almost totally achieved simply with the color tones used.

2 This second treatment is what I consider to be at the limit of attainable, believable atmosphere for a landscape. The vivid pinks and purples, while a definite component to a post-dawn, pre-sunrise sky, push the limits of what the viewer might expect to see in nature. The end result is very sci-fi.

3 The color theme in the third treatment takes the natural colors encountered on Earth and tweaks them towards a more red condition, while keeping the usual blue cooler tones seen at sunrise. Note how the dark blue-purples bridge the spectral gap between the primary red color and the complementary accented cyans in the lights and windows.

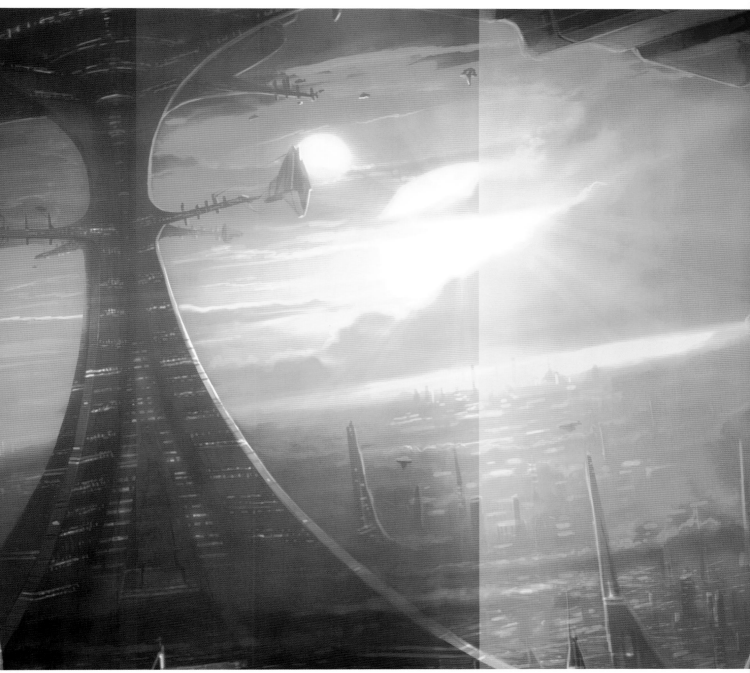

4 The palette in the fourth treatment is the closest to the original image, using a well balanced "golden hour" complementary palette seen in most sunrises. What is not immediately evident is the diffuse green-gray that I have employed to cement the atmosphere around the tower. This is much more important than it might appear at first.

5 Brilliant, golden light cascades into the final section of the piece. The bright sun overruns any subtle blues of an early sunrise. This color treatment has an epic, early morning, get-up-and-go feeling. Notice the subtle greens up close—they help balance the section with accented complementary hues.

LIGHT

Light is the origin of all art. Without light nothing is visible. That might sound like an obvious thing to say, but think about it for a moment. Light allows us to see what we are looking towards, what shape it is, how far away it is, what it is made of and what it might be reflecting. No small feat! To be able to recognize light as the origin of what we visualize is truly fundamental to a greater understanding of why everything we see appears the way it does. In turn, this produces a built-in ability to re-create lighting circumstances and effects that look believable and compelling, and capture the imagination and attention of a viewer.

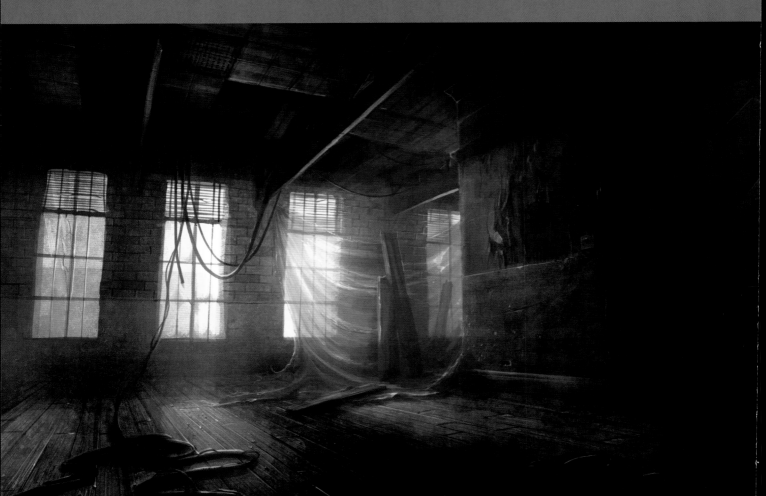

Light and Light Sources

Let's start with a "global" view of lighting and the basic effects that light creates.

Light Source
The sun, a blazing ball of nuclear energy, is our light source. This is the primary light source for our entire solar system, and it therefore plays an enormous part in any art that depicts the outdoors in daylight.

Lens Effects
Looking at a light source can cause effects such as glare, which simulates how the eyes may need to squint to compensate for brightness, as well as lens flares, which imply effects on optical equipment caused by light refractions and reflections.

Direct Light
The light striking the bright side of the Earth is direct light. This is the most basic type of luminescence, and many people assume it is the only type of light.

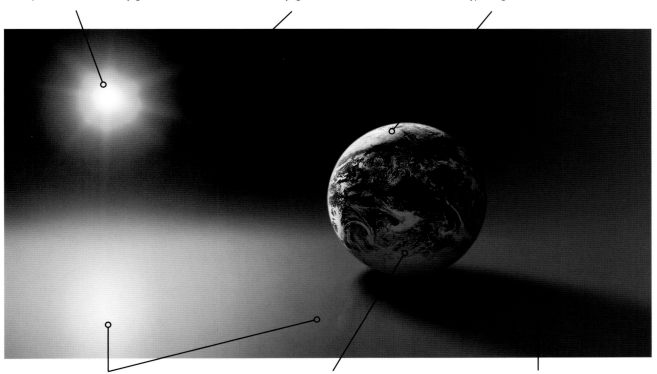

Reflected Light
While the surface of the floor is not reflective in the same way a mirror is, there are some subtle reflective effects visible. The underside of the Earth and the glow of the sun are both reflected on the floor.

Diffuse Light
The rest of the Earth is much darker than the directly lit area. The tones are similar in intensity to the shadowed areas of the floor, but not black. This part of the globe is in shadow, but the residue luminescence you see is referred to as diffused or bounced light.

Shadows
The most important thing is to understand what creates the shadow. The ground underneath the Earth is obscured from the sun's light and therefore does not receive any direct light from the light source.

Relationship Between Light and Matter

Building on our understanding of light, let's expand on how light is absorbed and reflected by diverse materials. Obviously every type of material and light cannot be covered in one lesson, but this should provide some insight on analyzing and understanding the different relationships of light and matter.

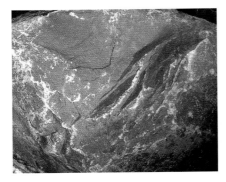 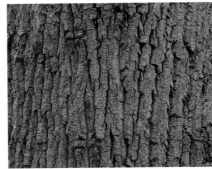

Matte Surfaces

Surfaces such as untreated wood and stone reflect light in the most obvious way, as if they are lit by whatever light is affecting them. Pay attention, however, to how the light articulates the texture of the surface and include these nuances in your painting. With this tree bark, for example, each groove casts a shadow, and deeper grooves cast deeper shadows. Try using a dappled, random brush shape when painting surfaces like this.

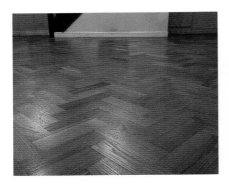 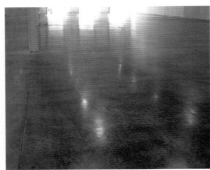

Shiny Surfaces

Polished wood, polished stone, plastics and wet materials reflect light more efficiently than matte surfaces. The reflective quality of shiny surfaces will appear as diffused, distorted or abstract reflections and sharper highlights. These may be visible only at acute angles or along edges or seams. Some soft color-dodge brush shapes are often enough to supply the impression of reflections on these surfaces.

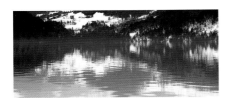

Reflective Surfaces

Metals, polished marble, mirrors and water repel light most efficiently. However, even on these kinds of surfaces, reflections will have inaccuracies such as minor distortions, bending or breakup due to the properties of the surface. Be sure to include these inaccuracies in your painting; a reflection is never just a flipped original.

Keep in mind that reflective properties are tempered by the color of the surface. For example, a red surface will only efficiently reflect the redder light rays and absorb the others. This also applies to the coloring of reflections where the other hues are slightly tempered by the surface color.

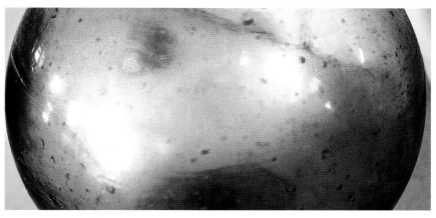

Transparent Surfaces

Glass, water and other transparent surfaces allow light to pass through and continue on. All materials have some effect on light, but this changes radically as the translucency level deteriorates from near perfect.

A piece of glass, for example, has a degree of refraction that distorts light coming through the surface. This is most evident when viewing glass from an acute angle. The more imperfect the transparent surface, the greater the effect of refracted and diffused light will be. In some cases, objects past the surface will be fragmented beyond recognition. Only the brightness of the area past the surface will be identifiable.

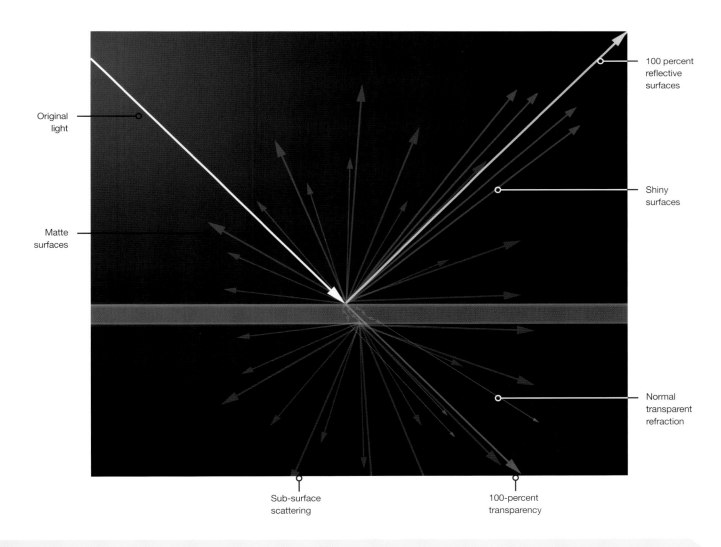

Original light

Matte surfaces

100 percent reflective surfaces

Shiny surfaces

Normal transparent refraction

Sub-surface scattering

100-percent transparency

Intermediate

Controlling Light and Shadow

Understanding how to control light and shadow in a scene is part common sense and part inspiration.

Here a single painting is used as a reference to discern the intricacies of lighting across the whole canvas and to get an idea of how lights and shadows break down.

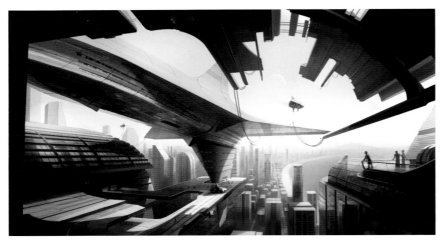

Positioning Light

Always try to show off subjects in the best way possible while maintaining a level of believability for the viewer. The positioning of light and shadow is as much of a compositional choice as the positioning of your focal points. Think about how best to position your lighting to get the most out of it.

Basic View

The light in this scene comes from a close-to-midday sun. The sky is cloudless and the air is clean. Knowing these details helps break down what is actually going on with the lighting.

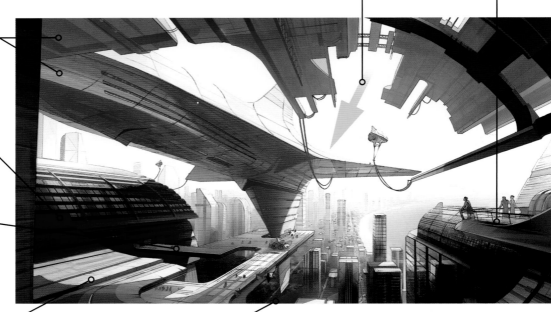

Direction of light source—the sun.

The platform is in shadow caused by the large hanger roof at the top of the scene.

The underside of the craft and upper part of the hanger are in shadow. They receive secondary diffuse light bounced from areas hit by direct light.

A striking shadow cast by the craft onto the building.

A second area in shadow from the craft. The two shadows combine to secure the vessel into position in the scene.

Areas hit with direct light from the sun at various angles.

The shadows on the ground (from the buildings) make up the mid-distance areas. Many more of these are seen in the distance than indicated here.

Diagrammatic View

The diagrammatic version of the image shows us exactly what is happening with the lighting.

Secondary Light Sources

Secondary lighting can come from other natural sources (two suns for instance) or artificial lights such as bulbs, neon, candles, etc. In this scene, the natural light is very strong so the artificial lighting is confined to the areas of emanation. However, there is abundant secondary bounced light.

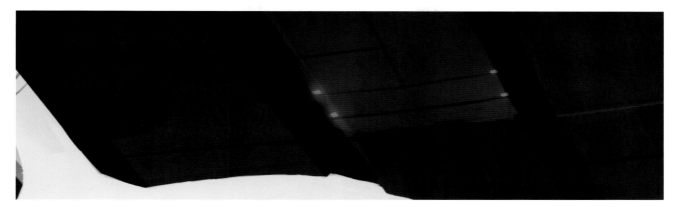

Sunlight Drowns Out Secondary Light

The top of the hanger has some little pin lights. In daylight they do not look very bright, and indeed they are not, compared to the light of the sun. If the sun were taken away from the scene these reddish lights, though diffuse, would be strong enough to illuminate the craft and the platforms below.

Use Secondary Light for Compositional Balance in Daytime Scenes

This scene shows evidence of other complementary colored light sources, namely, the red glow of the generator-shaped light. Again, if the scene were set at night, these reds would emanate outwards, lighting the local proximity in a red glow. But in a daytime scene, the sunlight easily overpowers artificial light sources and reduces them to complementary glows that help with compositional balance.

Advanced

Incorporating depth and cohesion between subjects and their scenes is paramount to achieving a believable final image. The image here demonstrates these effects.

Artistic License

Take time to understand light, shadows, diffusion of light rays, exposure levels and all the other subtleties, but look for ways to bend those rules to achieve the effects you want. I did some things that enhance this image, even though they may not be physically accurate:

- With the streetlights at the level they are, it is not likely the ceiling tiles would be lit as brightly as the floor, but adding the extra diffuse light made the image better.

- The exposure levels (looking towards the brightly lit windows) should pretty much blacken the area at the bottom of the stairs, but adding some light in that area helps the viewer understand the shapes better.

Lighting Balance

Keep your lighting balanced. Don't allow too much bleaching or blackening of scene elements. This is a technique of judgment more than anything else, and it is worth spending time analyzing the best photographic and artistic works to help you understand how to balance your images. Much depends on the number and intensity of lights, but for the sake of this demonstration, look over the image here and see what has been done to make this one work.

- The light from outside is just enough to make you want to squint but not so much that it obscures details in the scene.

- The dark areas have some details visible. Keep solidity to the scene by balancing the light subtly.

- Notice an implied light source at the top of the stairs. The subtle additional light is easy to overlook at first but is very important to the final piece.

- Note how carefully the surfaces are treated. The wood and ceiling tiles are reflective and therefore, more brightly lit—but in a way that complements the delicate lighting in the room.

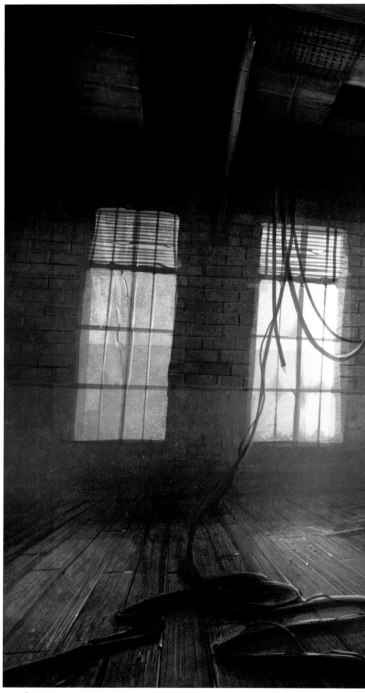

Artificial Lighting and Attenuation

The lighting in this scene comes from sodium-style street lights outside. Artificial lights dissipate over a much shorter distance than natural sunlight, and I made sure to depict that in this painting.

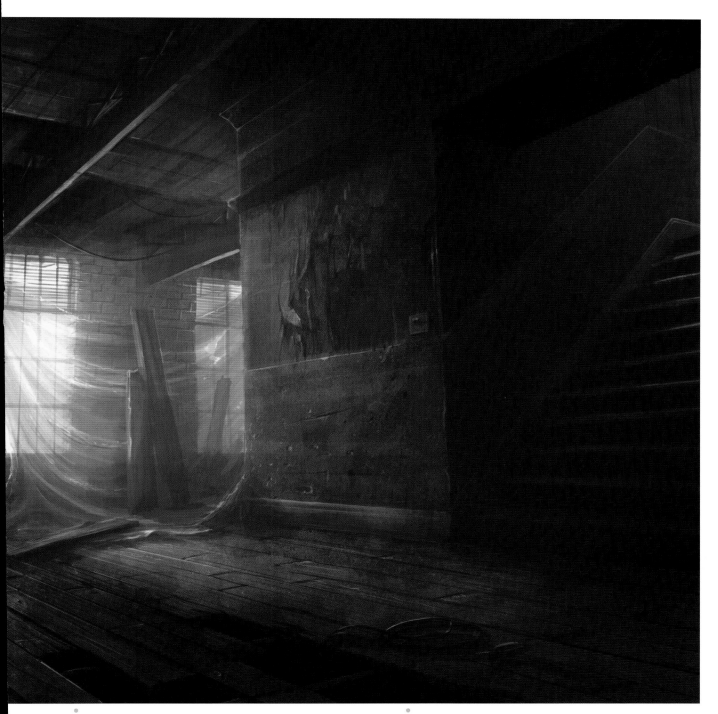

Diffuse Lighting

Consider the element of diffusion, or scattering. Here the light enters the room through dirty windows and some sort of semi-transparent tarpaulin. The interior of the room is dusty and damp. All these things scatter the light in various ways, resulting in soft lighting and shadows with some fogging towards the far side of the room.

Avoid Complete Black

Look at the dark areas of the scene. Pure black is not actually present. If it were, you would see nothing. Think about what color a dark area might be, even if struck by the most watered-down lighting. It may be very dark, and might even appear black, but it's probably not.

Get free downloads from Gary Tonge's *Bold Visions* at impact-books.com/digitalpaintingtrickstechniques.

41

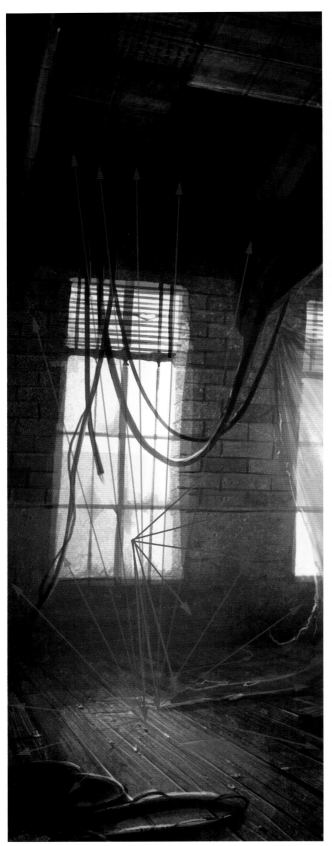

Bounced or Scattered Light

Bounced light is caused when light strikes any surface that is not pure black. The light scatters and continues outward, reduced in intensity but strong enough to subtly light another surface.

The red lines on the diagram simulate scattered light as it comes through the dirty window and then hits the wooden floor, creating more bounced light (blue arrows) that finds its way back into the room. Note how the bounced light finds its way into the dark areas above the ceiling, very slightly lighting that area.

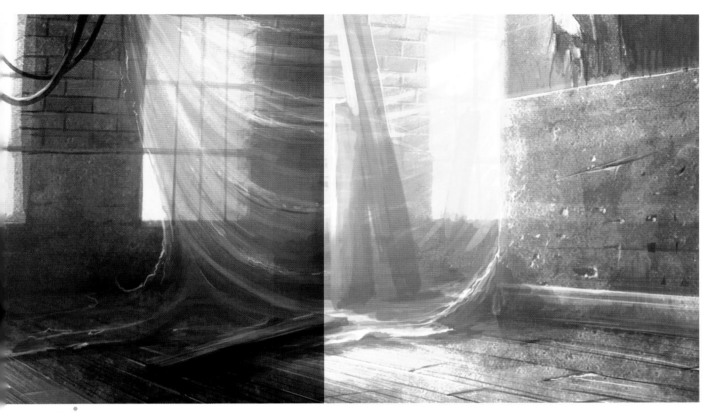

Exposure Levels

Exposure is the length of time the receiving medium (be that film or the human eye, for instance) is exposed to the pervading light. A dark room can appear completely black in a lower-exposed shot or more brightly lit in a higher-exposed shot, if your eyes have had time to adjust to the brightness in the room.

The outside area (which appeared normal when standing in it) now seems bleached out when viewing it from the dark room because the eyes allow for greater exposure in dark areas. Study this split image to get a sense for how radically the scene changes when the exposure levels are lessened (left) or increased (right).

You can quickly alter the exposure levels of your pieces in Photoshop using the tool found in Image> Adjustments> Exposure.

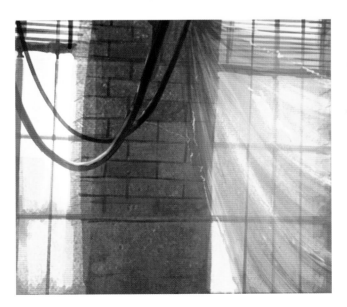

Bloom Effects

Bloom is the effect of light creeping into solid objects that are occluded by the light. Look at the window frames and tarpaulin to see this effect working in the scene. Most noticeable is the apparent thinning of the frame because the light behind it is blooming over it. This effect is useful for creating an impression of squinting to see something in bright light conditions. What you create is light overpowering the viewing device and causing glows around brightly lit objects. This also works in direct-light circumstances, where objects might glow due to high brightness and exposure levels.

COMPOSITION

Have you ever gazed upon an image that utterly captivated you and took you away to another place, or even made you feel like you were falling into the image? Chances are the careful amalgamation of solid perspective, balanced composition and great depth caused these feelings. The cornerstone of great CG art is a good mixture of these elements. The subject you paint does not have to be grandiose for the painting to work well, if you get these other elements right.

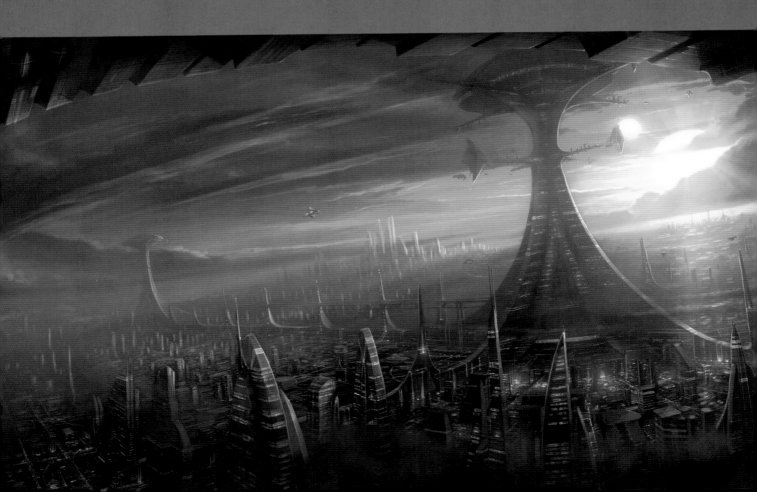

What Is a Focal Point?

The focal point of a piece is the part you really want the viewer to look at—the point of interest. It's important that the placement of the focal point complements the image as a whole. It should draw viewers into the image and hold their attention while they take in the rest of the picture. For simple images that contain few subjects, consider which part is most interesting to look at initially and make that the focal point. For more complex compositions, you might frame the image in a way that leads the viewer's eye from one focal point to the next.

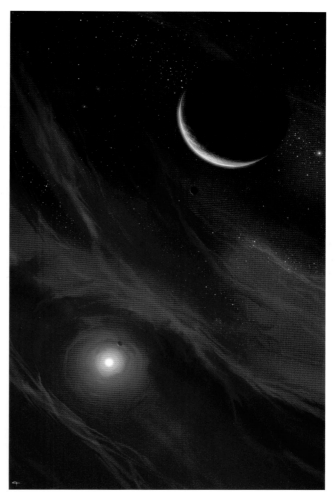

Single Focal Point

The threatening silhouette of the large mother ship strikes an ominous shape across the sky. The rock shapes frame the piece at the bottom left and right and serve to strengthen the focal point of the spacecraft.

Double Focal Point

For viewers inclined to look towards the light, there is a simmering star behind some etherial clouds towards the bottom left of the piece. But for viewers who prefer to find the detail in the darkness, there is the crescent planet towards the top right. Each subject frames the other.

Positioning a Focal Point

Positioning a focal point is just as important to the final piece as getting proportions correct. You could spend countless hours meticulously creating and painting a beautiful image, but all that could be thwarted if you haven't thought about how the image is laid out and how viewers will read it.

The simplest way to successfully position a focal point is the Rule of Thirds Method. Divide the width of the image into thirds, and then divide the height of the image into thirds also. The four points where the dividing lines intersect are ideal areas for positioning a point of interest within a composition. Placing a subject in one, two or even all four of these areas pretty much ensures that you have a good position for your focal point.

The key to successful focal point positioning is to loosely sketch out your ideas and move elements around until you get a balance you like. You don't need to add any meaningful detail to your piece to be able to see how well balanced it is. Get the focal areas right first.

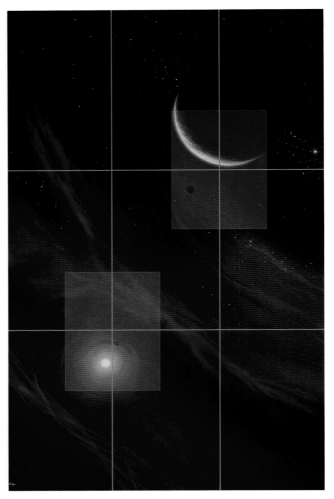

Single Focal Point

The mother ship is positioned across two of the sectors, slightly more to the right of the top third area. While two of the ideal positions for the point of interest are targeted, one is more heavily used than the other. The leading edge of the craft, two of the downward-pointing wings and the main central hub are all in the top right third.

Double Focal Point

A much closer balance between the thirds exists here. The star and the planet have equal importance within the sectors, giving the piece a delicate poise and allowing the viewer to gaze upon either subject without conflict. If you want to create this type of composition, be sure to balance the positions of the subject as well as their relative sizes. Note how the bright subject is smaller than the dark one, because light objects draw the eye more naturally.

Fundamentals of Perspective

Perspective and depth are two of the most important things to master in creating believable images. Perspective is the cornerstone of showing the scale and distance of subjects. Depth is related to perspective but is also an important facet on its own. Using perspective correctly is only half of the process; true visual success is achieved when perspective is used to create believable depth.

There is much to learn about using complex multiple perspective lines in creating images, but the fundamentals discussed here form the basis of all perspective rules. Get to know the basics before moving on to more complicated layouts and compositions.

Basic Linear Perspective
In a finished piece, often most of the vanishing points are off the canvas.

Three-Point Perspective
The perspective is exaggerated here to show all three vanishing points. Note the dimensions of the box and where it sits in space.

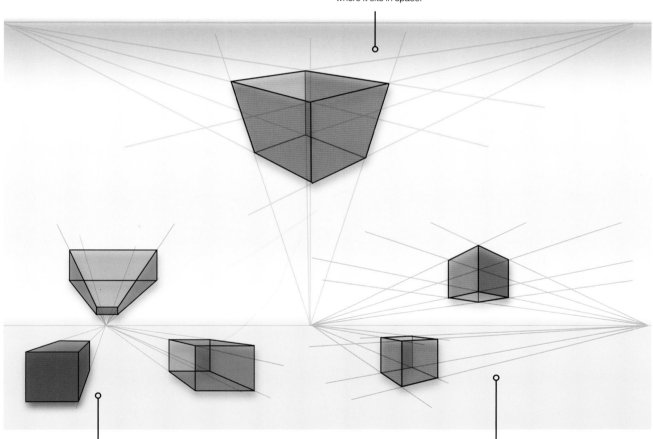

Single-Point Perspective
This simplest form of perspective is bound to only one vanishing point, which coalesces on the horizon. Lines emanate from the vanishing point, and as they widen, a single dimension of perspective is created. The other lines in these boxes are either vertical or horizontal, with no perspective origin to guide them.

Two-Point Perspective
The two vanishing points are both on the horizon but could be anywhere. The additional perspective origin allows viewers to visualize the shapes in a more realistic fashion and discern dimensions more clearly than they would with only a single-point perspective.

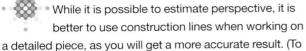

Practical Use of Perspective

While it is possible to estimate perspective, it is better to use construction lines when working on a detailed piece, as you will get a more accurate result. (To learn how to create construction lines, see the tip on using multiple perspectives in the advanced section of this chapter.) For now though, study the piece below to get an idea of where perspective has created depth and scale.

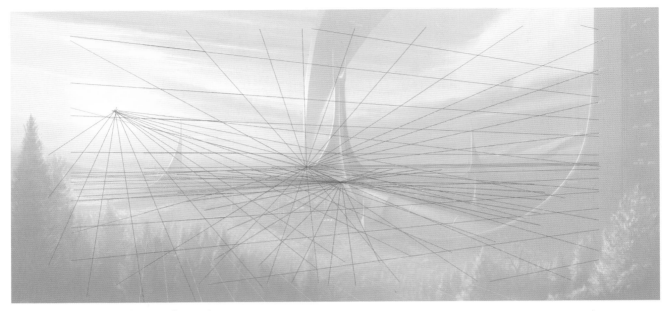

Points of Origin for Different Dimensions

The red lines represent the primary depth—the spurs emanating from the tower and the curved structure over the tower. Blue represents the width of the piece. Blue lines create the spurs emanating from the tower at right angles to the red-line constructed sections. They also help contour the ground. Green lines give the city surrounding the tower a point of origin. Yellow lines create the trees in front of the viewer. The purple lines make accurate shadows from the sun.

The End Result

Cohesion of scale and positioning of relative subjects along with constructed perspective are imperative to an image of this scale and amount of detail.

Intermediate

Compositional Framing

When creating an image, understanding how to frame and balance the piece is key to allowing viewers to get the most out of what they see. With this in mind, study this simple sketch. Ignore subtle details, light and color, and focus instead on how it has been composed and framed.

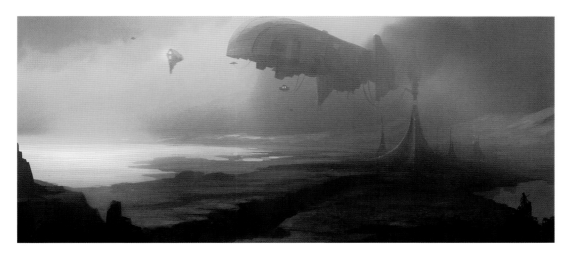

The Finished Image
The top of the tower and the rear of the vessel are the main focal areas in this piece.

Misty clouds create a ceiling in the image, giving the impression the vessel is pushed into the clouds and creating substance in the sky. The right and left areas have sections of water, which contributes an expansive feeling to the mid distance, particularly the left, where bright sunlight reflects off the surfaces.

The eyes follow the length of the craft from front to back and then settle in the focal area. This technique produces a nice depth.

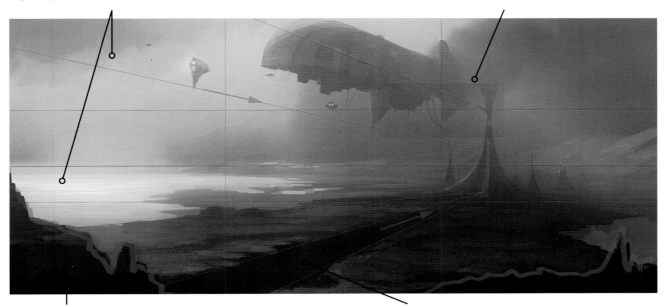

The rock silhouettes imply a proximity to the viewer and establish a sense of scale. The viewer will understand these rock shapes are a certain size and so the areas farther away must be very large. These shapes also help frame the left of the image, countering and balancing the focal area.

The small craft and the canyon towards the base imply a sense of movement towards the focal area. This quickly helps set up depth and perspective.

What Works as a Focal Point

There are many ways to create an engaging focal point for an illustration. Below is an image cropped in various places to show how different focal points can work, as well as how the lack of a good focal point can ruin a piece.

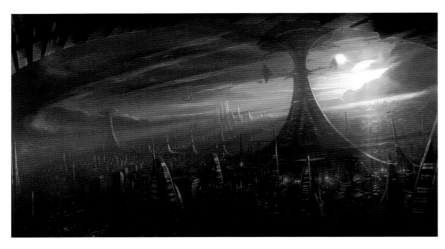

The Finished Image
The focal point on this piece is the tower closest to the viewer.

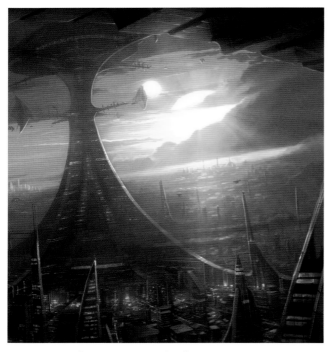

Crop 1, Complementary Focal Points
Cropped this way, the image has a unique balance of both the tower being in the top left sector and the larger sun being in the top right sector. With careful balance there can be areas of interest, or complementary focal points, across multiple sectors of an image.

Things to Avoid in Composition

- **Poor Framing**
 Don't overdo framing to the point where the viewer no longer looks at the focal point.

- **Excessive Detail**
 Refrain from over detailing parts (or all) of your piece to compensate for a composition you're not happy with.

- **Awkward Angles and Positions**
 When positioning a subject, avoid awkward angles that may confuse the viewer.

- **Dead-Center Focal Point**
 Compositions with a dead-center focal point draw the viewer's eye straight to the center so they pretty much ignore everything else.

- **Overuse of Color**
 Too many colors can lure the viewer's eye away from your focal point. Respect the power of color and use it with reverence.

- **Narrow Tonal Range**
 Even with a variety of colors, if the tones are all similar, the image will have a drab feel overall. Use a healthy mixture of light, medium and dark tones. Ratios in the range of 60/25/15 and 65/20/15 work well. (Use the Auto Contrast tool to check how well you're spreading your tones in an image.)

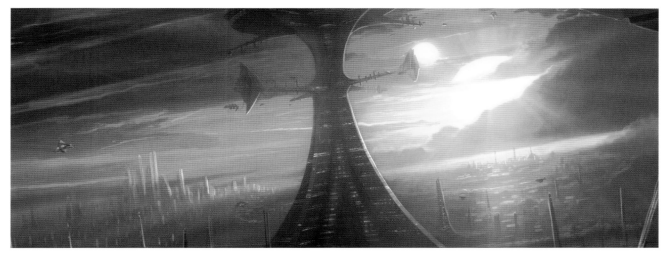

Crop 2, Wide-Aspect Ratio

This crop keeps the wide-aspect ratio of the original piece, but now the tower is positioned center, shifting the focal area to the twin suns. The image still works very well, despite losing the close-to-mid-distance ground.

Crop 3, Distant Focal Point

The distant tower, though small and diffused, supplies a good depth cue and focal area in this crop. This is aided by two other factors: the framing of the arched structure at the top and the secondary mid-distance complementary focal area of the pointed building at the bottom right.

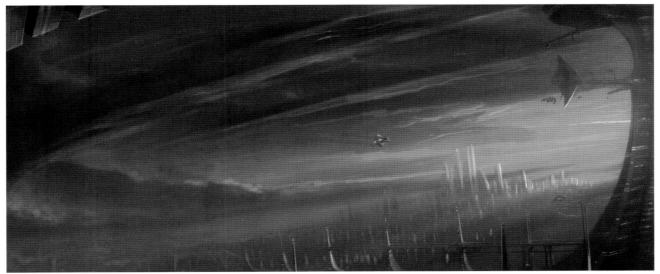

Crop 4, Poor Composition

The composition in this crop no longer functions well because the distant tower was removed. Many nice features are still evident in the piece, including swooping cloud formations, sunlight emanating through the sky, the distant city and the structural framing at the top left and right. However, it all falls flat because there is no real focal area to draw the viewer into the piece.

Avoid Tangents and Cropping Mistakes

In art, tangent shapes (shapes that are touching at the edges) can be visually uncomfortable for the viewer.

Tangents are actually quite easy to avoid. Below I have listed some of the most common tangent types found in any sort of image, with a couple of quick crops and edits on my work to demonstrate how to fix them.

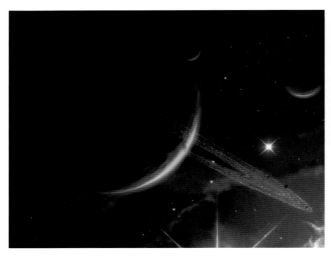

Fused Edges

When two or more objects in a scene have touching edges or touch the edge of the image, it crowds the composition and can be visually unpleasant. Viewers may not know what's wrong specifically, but they won't like it. Notice how uncomfortable this image seems, with the large planet touching both the left and top frames, as well as the moon touching the planet.

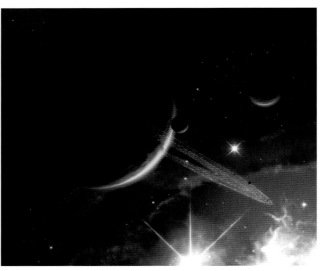

Fused Edges Fixed

Notice how much better the image looks now that there is space between the planet and the top and left frames. Also, the moon over-lapping the planet not only looks better but makes more sense visually.

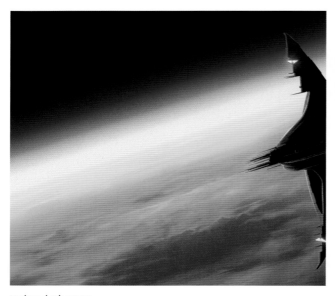

Halved Shapes

Cutting off shapes in a way that visually halves them creates a bother-some chopped feeling. Not only is this scene visually uncomfortable, it also makes viewers wonder why the subject is present at all.

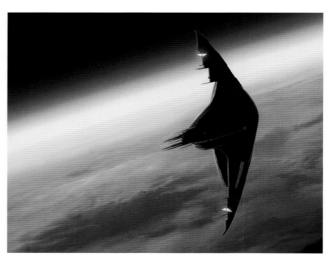

Halved Shapes Fixed

The ship is now fully visible, giving the composition balance and depth.

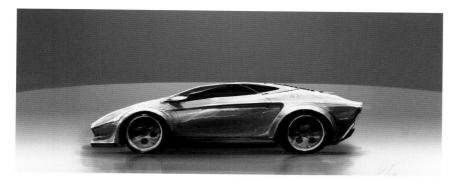

Stolen Edges

When a foreground or focal object edge aligns with a shape behind it, the edges of both objects are basically lost. Notice how the arching line behind the car damages the flow of the car's roof line.

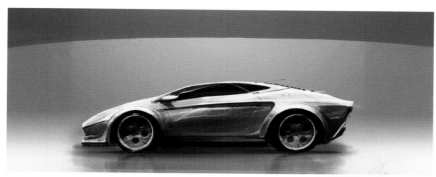

Stolen Edges Fixed

With the arched line moved up, the line of the car's shape is much more apparent.

Hidden Edges

If the edge of an object is occluded behind another object of the same orientation, it is possible for the two to look like they're together when they're not. The tower at the near end of the building appears joined to the larger structure, which might be what you want.

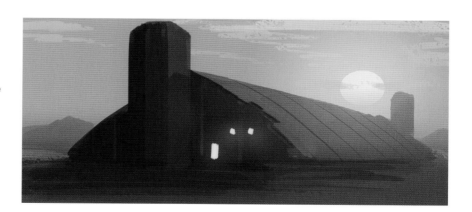

Hidden Edges Fixed

If you want the tower to stand independently, shift it away from the apex of the roof on the building. The result is a better sense of distance between the two objects.

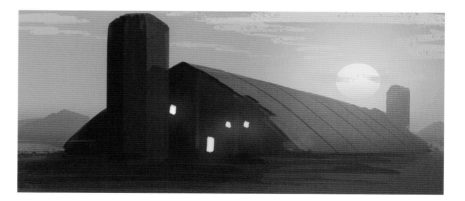

Coherent Scaling

Working within the rules of perspective lines creates an excellent framework for accomplishing coherent and solid scaling. Keep an eye on the scaling of objects in your scene, especially when those objects are relative to humans or the real world. (For a more in-depth study on scale coherence, see Chapter 7.)

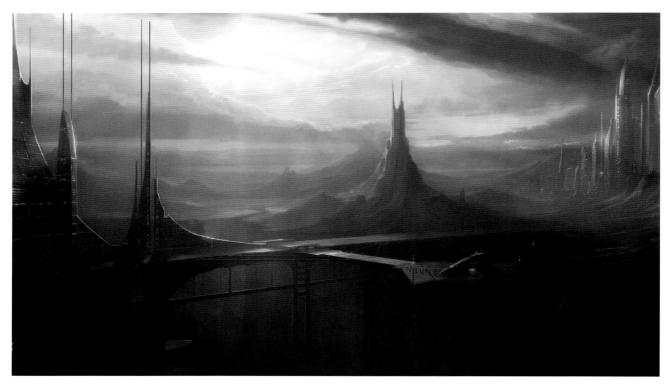

Techniques for Communicating Scale

Several techniques were used to create the sense of scale in this scene:

- From the landing lights on the platform to the sun in the sky, the progression in size from smaller objects in the foreground to larger objects in the background allows the viewer to take in the epic nature of the scene.

- The lighting and atmosphere assist greatly in generating believable scale. The viewer sees objects diffused into the background or silhouetted against the sunlight and reads their position in the scene based on that lighting and atmospheric information.

- The sun and moon tell the viewer there is a vast world beyond the horizon.

- The towers and city imply human efforts to construct habitats in this world. The platform in the middle of the large canyon gives a good scaling reference to the magnitude of the rocks and cliffs. The landing craft and the tiny human figures solidify the true scale of the scene. Real-world elements such as humans, vehicles or animals help to clarify scale.

Leading the Eye With Perspective

Now that you understand why it's so important to get perspective and composition right, here are some of the exciting things that can be achieved with the clever and balanced use of these effects.

Focal Point
The blue lines move the viewer's eye towards the focal area, creating the feeling that one could fall into the piece.

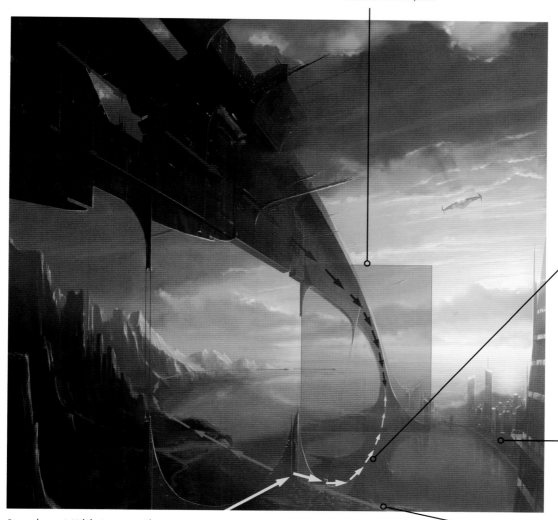

Ground and Base of the Arch
The yellow lines track the floor underneath the arch. They follow the rules of perspective, but their gentle shape helps underline the depth and drama of the composition. These lines meet the blue lines at the focal point.

City
The green lines are more subtle but have a gentle perspective adherence. They invite the eyes to follow the shapes towards the focal point.

Landscape
The pink arrows show a swooping motion that holds the viewer's eyes inside the piece, allowing them to roam while always returning to the focal area.

Experiment With Perspective

The perspective lines have been followed to a large degree but deviate slightly where the structure bends towards the ground.

Leading the eye like this can be a fabulous way to enhance depth, balance composition and create drama. Use perspective as a foundation to experiment with ways of drawing viewers' eyes towards a focal point, or even on a journey around the image, as this piece demonstrates.

Drama Through Composition and Scale

Building on what we explored in the previous tip, take a look at the various elements that can help create a sense of drama and excitement.

A large focal area with the exploding tower lights up the distance. The smaller framing aspect of the two buffoons who have caused the explosion occupies the foreground. The fundamental drama of the painting is augmented by the contrast between humorous and cataclysmic elements in this image.

The two sets of parallel cables connecting the left and right of the image to the tower in the distance help amplify the depth and drama of the piece while leading the viewer's eyes towards the focal point.

Apocalyptic colors help drive home the message that things on this planet are not going well.

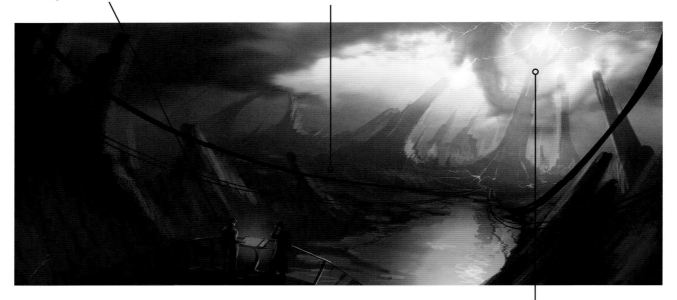

The field of view is a wide angle from left to right. Such an angle increases the amount of drama in the image.

The slightly off-vertical angle gives the impression of speed and drama. The movement created is a dramatic swoop from the top left of the piece towards the focal area, drawing the eye towards the explosive event.

A brightly lit focal area draws the eye and, used with some silhouettes for the closer objects, helps create dramatic lighting. The light emanating from the focal area appears much brighter than any ambient light, underlining the explosive drama in the distance.

Using Multiple Perspectives

Working within the rules of perspective lines makes the challenge of aligning, scaling and positioning scene elements much easier. However, complex images require multiple perspectives and points of origin, depending on the orientation and shape of objects in the scene.

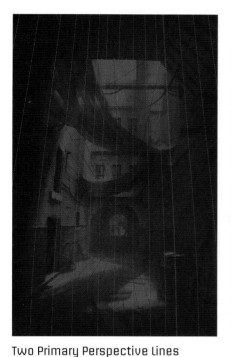

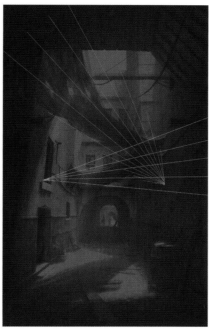

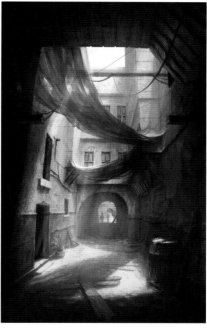

Two Primary Perspective Lines

The depth of the piece is illustrated by the blue lines. The view is down a thin, tall alley, and the vanishing point is somewhere behind the visible area.

The red lines supply the scene's vertical element. They are not exactly straight, giving the scene a sense of lens distortion and "visual error." This creates a greater sense of realism and scale.

Multiple Vanishing Points

The yellow and green lines demonstrate the value of using multiple perspective vanishing points. These other vanishing points, relative to the main composition, make it possible to achieve interesting and diverse shapes that also add to the depth of the scene.

The Final Piece

Many interesting and depth-producing shapes and objects are present. One of the reasons this image looks so natural is the inclusion of asymmetrical and offsetting items in the scene. Note how the swaths of cloth hanging across the alley break up the otherwise symmetrical area.

Add Lens Bend and Perspective Distortion

One of the most profound anomalies about how we see things is the way we subconsciously expect an element of asymmetry and error in what we see. To the human eye, perfectly vertical and horizontal lines look sterile and lack realism.

Create perspective lines that have a lens bend effect, which gives anything painted around them an organic "error" while retaining uniformity to the distortion on the perspective.

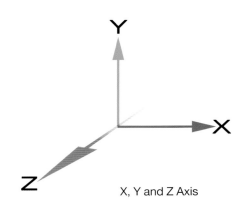

X, Y and Z Axis

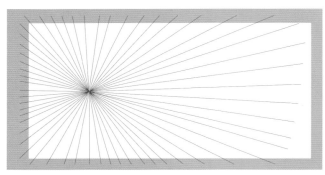

1 CREATE A NEW CANVAS
Begin with a small canvas (about 2000 × 1000 pixels). Do not use too large a canvas as you will need to add substantially to it in the following steps. Create a new layer and add the first set of perspective (Z axis) red lines. These will establish the depth.

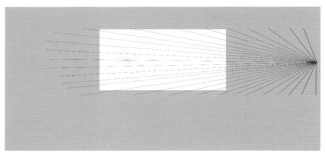

2 CREATE ANOTHER LAYER
Expand the canvas size using the Canvas Size option in the image menu. For this image the canvas was expanded to 5000 × 2500 pixels (bottom weighted).

Once the canvas is at the correct size, add the second set of perspective (X axis) blue lines by using a vanishing point that is substantially off the main canvas area. You should now have an image that has a background layer and two other layers, both with individual lines.

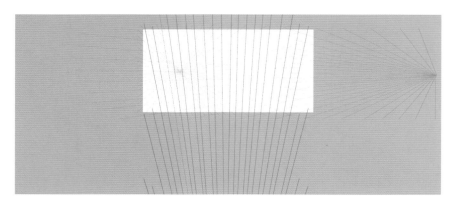

3 CREATE THIRD PERSPECTIVE LINES
You can cheat a little on the third perspective (Y axis) green lines. Make a duplicate of the second layer and rotate it clockwise by 90°, creating a set of vertical lines. Then move the origin so it is totally off canvas and scale the lines until you are happy with them. You should now have three sets of perspective lines—X, Y and Z.

4 CROP THE IMAGE

Crop the image down to the correct scale. Note the box in this image—it has been placed on a dummy layer to illustrate how to create the perspective distortion. To begin bending the perspective lines, select the layer with the X axis blue lines and then use the rectangular marquee selection tool to grab the area indicated by the box.

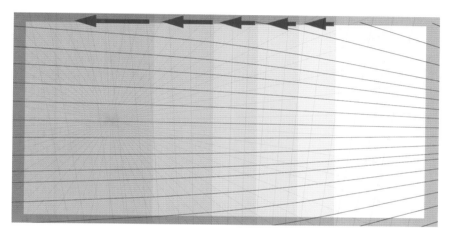

5 DISTORT PERSPECTIVE LINES

Stretch the selected area towards the left. Keep the area to the right in place, lessening the splaying of the perspective lines. Stretch a smaller area (shown by the next chunk of blue box). Continue expanding each selected area about 15 to 20 percent, reducing the amount selected from the left each time. The perspective lines towards the left of the image will be far less angled than the ones to the right, creating a look similar to lens distortion.

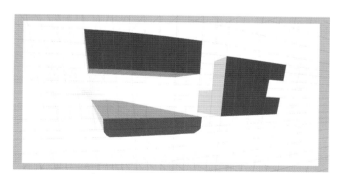

Apply to Other Shapes

Any shape drawn using the blue lines from the final step as a guide has an interesting and subtle distortion along its X axis.

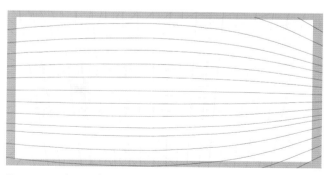

Keep Experimenting

You could also create distortion on the Y axis or even have the lines begin to converge again on the left side as this image illustrates. Keep practicing and experimenting with these techniques to get the best results.

TEXTURES & SURFACES

Understanding how to interpret and integrate believable surface types and textures into your paintings is a vital part of producing interesting imagery. The digital medium offers endless possibilities; the key is to develop a repertoire of techniques that suits your style.

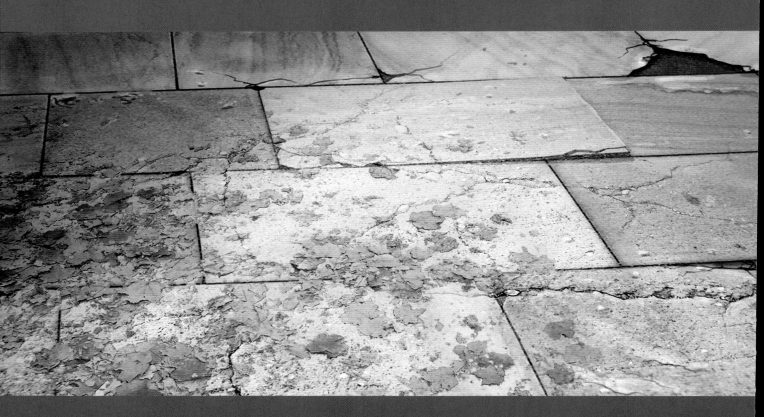

Beginner

Surface Texture and Lighting

Changing the type of surface in just one element in a scene can totally alter the lighting as well as the overall mood of the scene. Analyze the images below to see just how powerful material effects can be when changing a single element, in this case the floor surface, from shiny and smooth to matte and rough.

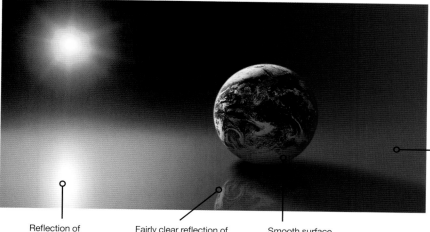

Polished Surfaces Are Highly Reflective
The polished surface allows ample light to bounce away from it, providing nice reflective qualities.

Ambient tone of the floor is light

Reflection of the light source

Fairly clear reflection of the globe on the floor

Smooth surface bounces light upward into the shadowed area of the globe

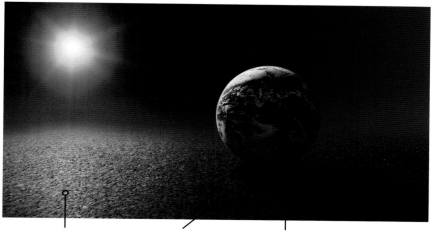

Rough Surfaces Alter Reflective Qualities
The overall brightness is altered by the more dappled surface not allowing as much light to escape, and scattering light that does escape.

Light source reflection is almost completely muted

No globe reflection, as the surface is now mottled and articulated

Shadow side of globe is darkened due to receiving less bounced light

Surface Texture Affects the Entire Image

Diverse textures affect everything around them. A rusty piece of metal doesn't just look different than a shiny new piece of the same material, it also:

- Alters the amount of bounced light, scattering and muting it greatly

- Reduces surface reflectivity due to corroded effects

- Picks up more dust and dirt

Intermediate

Matte Surfaces

The key to creating matte surfaces is to remember that they scatter light, literally bouncing it off in every conceivable direction.

The hanging wires catch the light in a way that allows a reflective lighting. Even the dusty spider web has a little shine to it.

Surfaces like concrete and bricks show subtly in reflected, diffused light. It's important to include textural detail, such as brick patterns and cracks in the concrete.

The addition of rust, peeling paint and corrosive effects to the large old tanks and pipes gives the impression of a old and neglected area.

Lots of dirt and dust has settled along the floor and pipes, reducing the reflectivity of those surfaces.

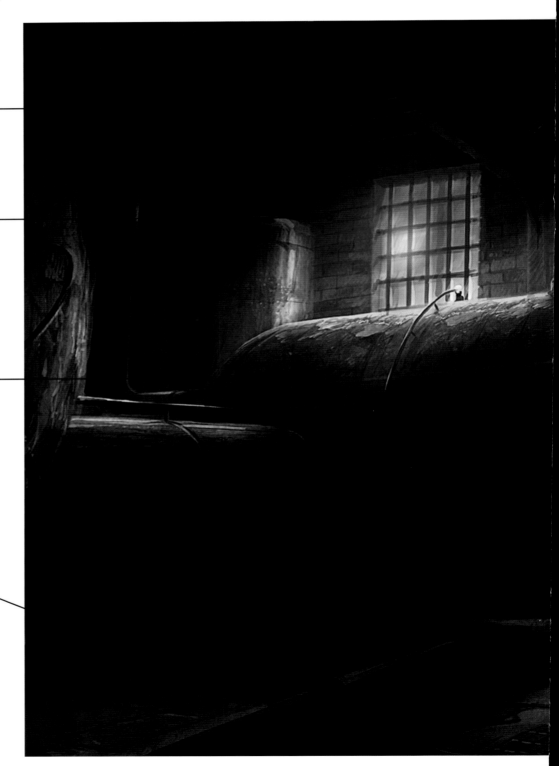

Dirt and Dust

Dirt and dust reduce the reflective properties of all surfaces—transforming them from shiny to matte. Dust also adds a subtle but effective texture, somewhat blunting the scene. Floating dust allows shafts of light to be seen.

Semi-Reflective Surfaces

A surface that was once shiny but is turning dirty and rusty is likely in transition as far as the way it reflects and transmits light. A good example of this is the tanks in this piece—they still have some reflective properties where the paint and metal have not been completely overrun by dirt and corrosion.

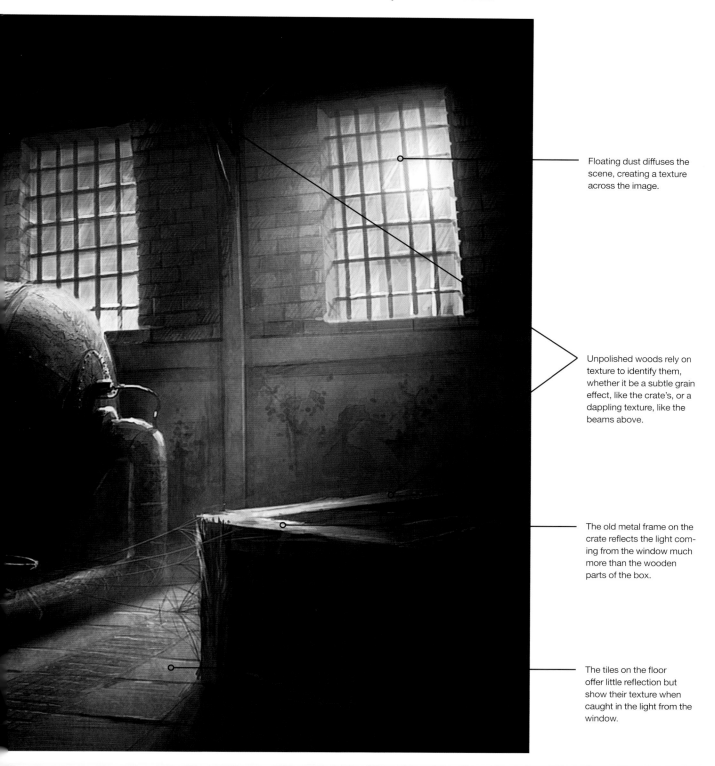

Floating dust diffuses the scene, creating a texture across the image.

Unpolished woods rely on texture to identify them, whether it be a subtle grain effect, like the crate's, or a dappling texture, like the beams above.

The old metal frame on the crate reflects the light coming from the window much more than the wooden parts of the box.

The tiles on the floor offer little reflection but show their texture when caught in the light from the window.

Surface and Material Types

Here is a selection of material types. Explore the unique properties of each one and learn what to look for when interpreting them artistically.

The demonstration on adding image texture that follows this lesson can provide additional insight into specific Photoshop techniques for creating surface textures.

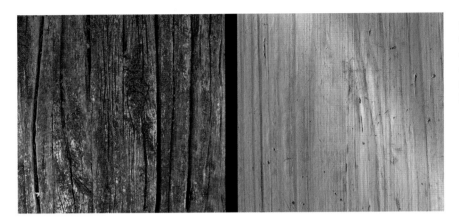

Woods

Wood surfaces range from a polished floor with no damage and nice reflective qualities to old decaying wood that is fraying and breaking apart. The key to painting wood is creating a believable grain.

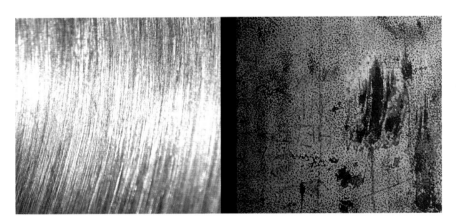

Metals

Metals can be pristine and polished or corroded, dirty looking and full of imperfections like dents, holes and scratches. Consider where the metal is, how long it's been there and how it's been treated. Then decide whether it would produce a clear or muddled reflection.

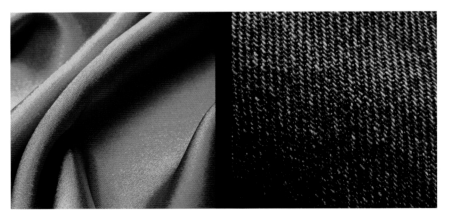

Fabrics

Unless they're silky, fabrics diffuse light that strikes them. Don't worry about getting patterns exactly right. Just illustrate the fabric in a way that lets the viewer follow its pattern as it creases and folds over the object it covers.

Concrete

Concrete, asphalt and other poured surfaces have components that can give them a faux natural look. As concrete ages, parts lift or crack and grass and other organisms eat through the surface. Identify these interesting areas. They are errors and natural influences that give the surface character.

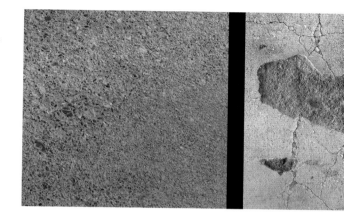

Stone and Rock

When cut to shape, like granite tiles, stone can have marbling and a polished look. Natural rocks and stones are susceptible to contamination and plant growth, so add moss, grass and dirt to the rock texture.

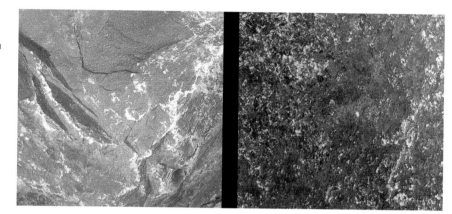

Natural Ground Surfaces

Nature scatters its goodness in an asymmetrical way. When illustrating natural surfaces like sand, dirt and grass, include elements of continuity in your textures but also give them unprocessed, non regimented details.

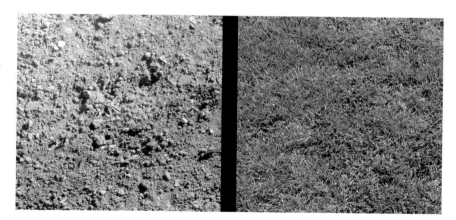

Add Image Texture Quickly

This effective technique for quickly adding asymmetry to break up a clean and sterile image is best used while you are working up details. The additional layering of noise and brush effects can help you loosen up as well as augment the overall feel of the piece. While this is a simple technique in principle, it is important that you do not over texturize the image and lose the original details underneath the overlay.

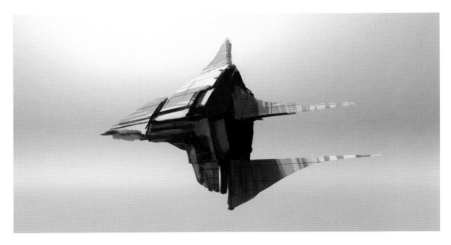

1 PAINT THE SUBJECT AND ESTABLISH THE LIGHT SOURCE
Paint a quick shape onto a new layer. The background should consist of only a simple color at this point. Be sure to establish the direction of the light source.

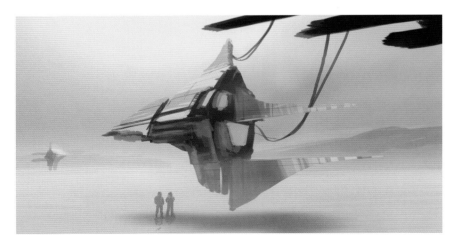

2 ESTALISH SCALE REFERENCE AND ADD SHADOWS
Establish real scale reference. (See Chapter 7 for more information on scale.) Here I placed two pilots in the shade of the closest craft. To help solidify these elements together, paint in some simple shadows.

3 ADD DETAIL AND TEXTURE

To add texture and interest without having to spend a long time detailing it, take a photograph of a piece of concrete and play around with the colors a little. Once you have an interesting image—most importantly, nothing with repeating or strong lines—simply grab the entire layer from the layers palette and drag it onto the main image. Scale this new layer so that it fits the image beneath, and set the blend mode to Screen. At the same time, set the opacity to about 20 to 30 percent.

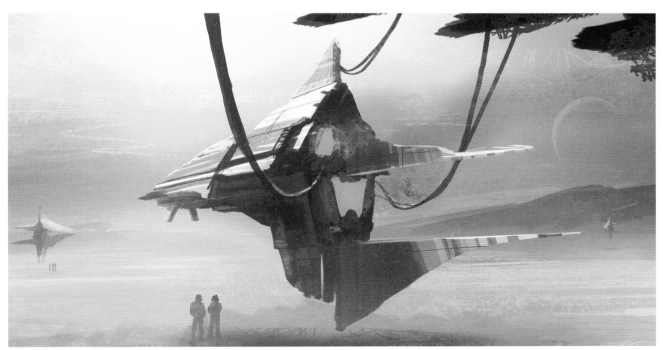

4 FLATTEN THE IMAGE AND CONTINUE PAINTING

You might find that certain parts of the overlaid texture stand out more than you want. To rectify this, simply select a soft large eraser brush and gently rub those areas out. (Set your brush to 50 percent opacity so you do not accidentally remove all the overlaid texture.)

When you are happy with the effect, flatten the image and carry on painting. You can very quickly paint over the image with a couple of custom patterned brushes (see Chapter 1) to help break it up a little more. The end result is an interesting and textural image without the time needed to paint details.

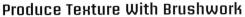

Produce Texture With Brushwork

Study the brushstrokes in the piece below. Many of them are very loose, to the point where they look like they were applied with a mixture of styles. Once you have the basic shapes of your composition in place, however, these messy and loose brushstrokes can be used to great effect.

Use Light to Add Texture and Detail

Highlights and light sources can be just as effective at increasing texture and detail as textured surfaces can be. Remember, it is not just about the pattern of a material; it is the way light plays off it.

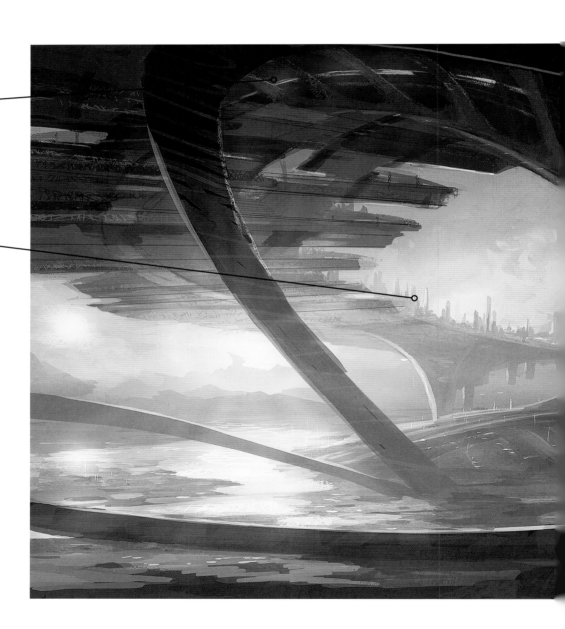

Other scattered light points imply lit rooms and landing lights.

Loose highlights in the distance indicate the origin of the sunlight. On the bridges, simple shapes for buildings and highlights imply that there is a lot going on back there.

The textures here make the viewer wonder what these materials might be. Metal panels? High tension cables? All were created with quick and loose brushstrokes.

For textured and impressionistic images like this you can afford to spill over the edges of shapes a little.

Loosen Up

Once the main parts of the image are in place, you can loosen up your painting. Try different brushstrokes and effects to infuse texture and break up the sterility.

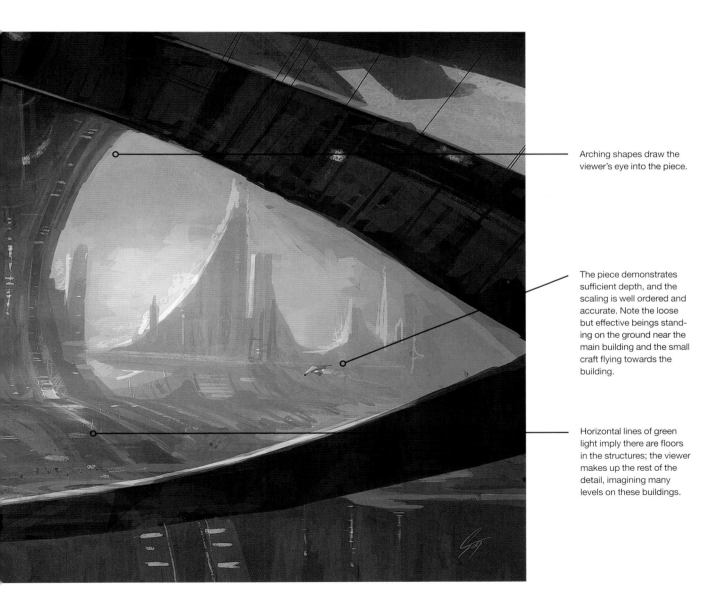

Arching shapes draw the viewer's eye into the piece.

The piece demonstrates sufficient depth, and the scaling is well ordered and accurate. Note the loose but effective beings standing on the ground near the main building and the small craft flying towards the building.

Horizontal lines of green light imply there are floors in the structures; the viewer makes up the rest of the detail, imagining many levels on these buildings.

Metallic and Shiny Surfaces

All shiny surfaces reflect light, but the effect varies depending on the type of surface. There are many degrees of shininess and reflectivity, and certain materials behave differently at different angles.

Glass/Clear Plastic
Glass and clear plastic reflect light, but they also behave differently under different circumstances. (See the next tip on viewing angles.)

Brushed Metal
Brushed metal reflects much of the light that strikes it, but the light scatters. This creates ambient coloration of the area around it.

Mirrored
A mirrored finish, like these car windows, reflects pretty much all of the light that strikes it.

Polished Paint
Paint can be polished to a point where it reflects very well, but it has other elements that need to be taken into account. (See the next tip on viewing angles.)

Dull Metal
Dull metallic surfaces like these wheels produce slightly distorted reflections due to carried-over bounced light.

Polished Metal/Chrome
A chrome effect produces a near-mirror finish as seen in this image of a wheel. Chrome behaves very much like a mirror, though reflections may be distorted by the curves and edges of objects that are chrome.

Viewing Angle Affects What We See

Although a bit complicated, the following information is valuable for producing any reflective surface that is not a mirror. Transparent surfaces such as water, or polished painted surfaces that have a color, are all influenced by what is known as the Fresnel effect.

The Fresnel effect is the observation that the amount of reflection you see on a surface depends on the viewing angle. So the more acute the angle, the less you see of the actual surface and the more you see of the reflection in the surface.

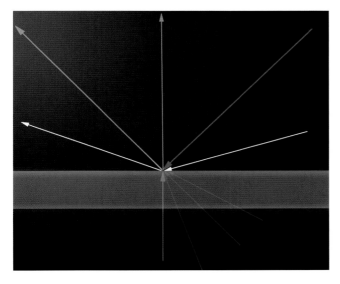

The Fresnel Effect

The blue arrows represent vertically viewed light going straight through the surface to the viewer.

The bold red arrows represent light striking from a 45° angle, more inclined to reflect than from a vertical angle. So the cumulative light (represented by the green arrow) is a mixture of the reflection of what is above the surface (bold red arrow) and the refracted light coming from beneath the surface (represented by the light red arrows).

The white arrows represent a glancing angle of 20 degrees (eye-level near the water). This creates much more reflection on the water surface, greatly decreasing the chance of seeing anything from beneath the surface.

Transparent Surface, Vertical Angle

The pattern of the tiles on the pool floor is heavily refracted and their blue tint has affected the color of the water. The shadow on the pool floor is visible. Some highlights on the water surface are also visible.

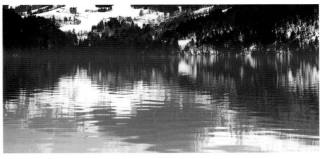

Transparent Surface, 20° Angle

In this image the Fresnel effect has created a mirrorlike finish to the water, and nothing is visible beneath the surface.

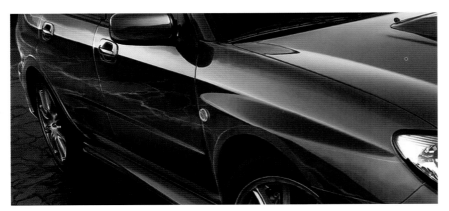

Examples of the Fresnel Effect

On the right side of the image the bodywork reflects some of the sky and surrounding landscape, but there is still a strong blue color to the paint. On the left, as the viewing angle becomes more acute, the reflections become more apparent and the color of the car is greatly muted.

Complex Surfaces

Take a look at some of the more complex surface types and some information that will be useful for re-creating them in a painting.

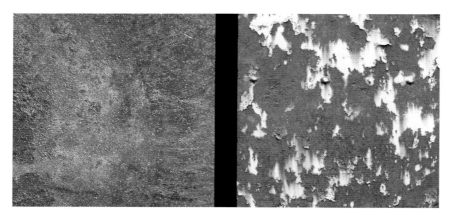

Plastics

Plastics can be opaque, semi- or fully transparent, patterned, mottled, shiny, matte or colored. They are among the most difficult surface types to replicate properly and to make look interesting. As a general rule, avoid depicting plastic in an illustration unless there is good reason to do so.

Corrosion

To paint corrosion effects well, study real-world objects and photographs. Corrosion often starts near joints, weld points or where paint has been scratched. Iron rust is the most common form of corrosion, though other types exist. Even glass can corrode.

Flora

Asymmetry abounds in flora. There are no regimented shapes, but there may be patterns across leaves and flower heads. Many smaller plants and flowers are transparent against the light, which scatters, passes through and picks up colors. Plant tissue is rarely opaque unless it's substantial, like a tree trunk.

Glass

Glass can reflect, refract and display levels of transparency from opaque to completely transparent. Study is key here—grab a few glass objects, sit them next to each other and look at the way light plays off and flows through each of them. Learn to express this in your paintings.

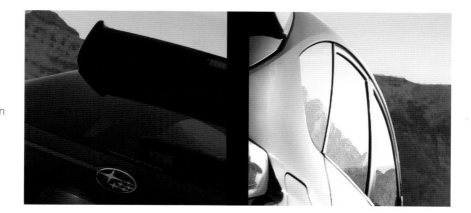

Water

Water can be clear, reflective or even opaque (if dirty). When viewing water from outside, think of it as a surface like glass. Also consider its three-dimensional composition. Unless totally pure, water abounds with particles that build up as you look into the distance. It's like looking into fog. Any light entering from above will cascade down in visible streams.

Ice and Snow

Ice can behave like glass—refracting, reflecting, etc. Snow might take on the look of white powder. It scatters (refracts) light everywhere, but it's essentially clear so much light escapes. This is why it appears to be the same color as the nearest light source. Snow is not white, it just transfers the local ambient lighting very well.

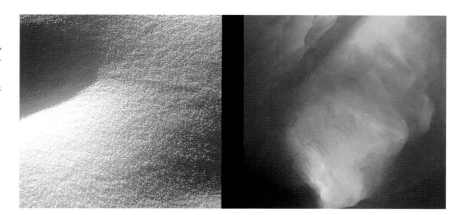

Add Organic Realism

Almost everything has a degree of asymmetry, structural error and organic realism. Even buildings have slight deviations when it comes to vertical and horizontal absolutes and perceived precise angles. Adding elements of asymmetry and organic scattering helps create images that are more natural to the viewer. Explore what can be done to make a smooth, paved surface more interesting and visually striking.

1 START WITH THE ORIGINAL IMAGE

There is nothing specifically wrong with these granite-style paving slabs the way they are currently painted. In fact, the staggered pattern prevents unrealistic perfection, and there are even some minor errors and dust particles present. To make the slabs look more visually compelling, add elements of weathering and use.

2 BREAK UP PARALLELS AND ADD CRACKS AND DIRT

Play with the positions of the slabs. Imagine that some may not be sitting at an equal height. Angle some of them to help break up the parallel lines. Add cracks to give the impression that the slabs have been there for a while, and weather and wear-and-tear have taken their toll. Add dust and dirt to further indicate that this surface is exposed to real-world elements.

3 INTEGRATE ORGANIC ELEMENTS

Weave in organic elements for an even more weathered look. Add some autumnal leaves lying on the pavement to effectively break up the symmetrical parallels, as well as make the scene look more believable.

4 ADD VARIATIONS IN TONE

Use lighting and shadow to help frame repeating areas. Add a gentle tonal difference to the top left corner of the piece. This changes the perception of the paving by breaking up and offsetting the parallels and symmetry a great deal.

5 THE END RESULT

This edited image offers a lot more life and interest. Cracks have started to form due to the uneven foundation. It could use a good sweeping and maybe some maintenance to get it back into shape. But most importantly, the intricate and diverse texturing breaks up the symmetry and repetition of the surface, making it look more realistic.

SCALE & PROPORTION

As you grow more creative, skillful and efficient with your digital painting abilities, it is paramount that you underpin your artistic efforts with sound scale and proportion control. There is little more tragic in art than an otherwise well-painted image full of scale and proportional errors. In this chapter, we'll focus on some of the most important things to keep in mind when applying scale and proportion in your art.

Beginner

The Importance of Scale and Proportion

Sometimes artists do not give much thought to the scale of subjects in a painting. When copying directly from nature or still life, for example, it's easy to forget these factors. But if you don't pay attention to the relationships between subjects in everything you paint, you will not learn how to integrate the same relationships and scaling references into an original piece.

Proportions are just as important as scaling and can also be overlooked. Especially when working with structures, it is important that even the most extreme sci-fi illustration has a sense of proportion. Likewise with human, natural or animal subjects it is plausible to play around with the shapes and proportions of creatures and flora, but you can only push proportions so far without breaking the viewer's illusion.

Take every chance you have to see not only the objects before you but also the relationships between those objects. If you are going to create an accurate rendition of a real-world object, it is imperative that you get the proportions right.

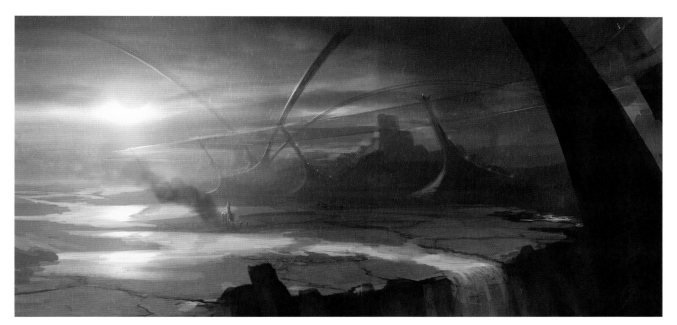

Pay Attention to Scale and Proportional Relationships
The size and position of one object augments other objects. Note the way the small craft and even smaller people in this scene are dwarfed by the enormous structures all around them.

How the Eye Interprets Scale

Many important techniques to establishing a good framework for scale are based around composition and perspective (see Chapter 5), so weave those techniques into what you learn here.

The human eye works out the scaling of objects by using their relative scale. This means that we interpret the size of an object based on the relative size of everything surrounding it. This is the cornerstone for creating your own distinctive scaling.

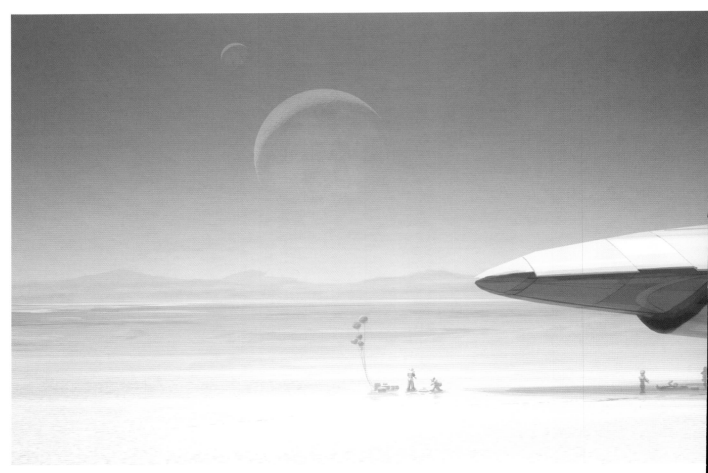

Simple Scaling

This image has an easy-to-interpret scale without any complex elements, like perspective, assisting it. The people are very small in comparison to the spacecraft over them. In turn, the spacecraft is quite small compared to the salt-flat desert surrounding it. The scale is further established with the blue sky and the distant moons.

Cropped Image

Although much of the composition is removed here, the scale is still recognizable due to the relationships between each element.

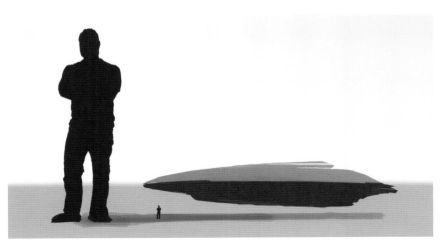

Changing Scale and Proportion Changes the Illusion

Here there are two figures: one small enough to be the pilot of the craft and one big enough to use the craft as a body board. The horizon is still in about the same place, but the absence of the sky, moon and other details creates the impression that the craft is small and the figure underneath the craft is probably a toy. This is all based on the relationships between objects in the scene.

Intermediate

Human Proportions

There is much to learn about the nuances of animal and human anatomy, but for these purposes, focus on the essentials of creating and modifying beings of believable (not necessarily realistic) proportions.

It is not the different scales and proportions that can break the believability of a creature/human study, it is the proportional coherence of that body. The main thing to remember is if you apply a rule change to create a different being (oversize head, extra long legs, etc.), it must be applied in a way that complements the rest of the figure.

The chin is 7 heads high.

The nipples are about 6 heads high.

The navel is 5 heads high.

The center of the body is 4 heads high.

The knees are 2 heads high.

Human Adult Male Proportions

The human form can be positioned in an infinite array of poses but there are proportional rules to follow. This diagram shows a human figure broken into eight chunks. Each chunk is the height of the head—this is how we scale humans in an image. The male human figure is usually 8 heads tall.

Proportions seen here represent ideal human adult male scales. There is, of course, a large diversity in proportions among the human race. For instance, a human child might be only 4 heads high. Likewise, if you were to create beings from another world, the proportions would differ again.

Vehicle and Structural Proportions

Vehicle and structural proportions are just as significant as humanoid ones. With vehicles in particular, there are key lines and shapes that resonate with the viewer at a subconscious level.

It is possible to play with proportions to make different and interesting variants. A few proportional alterations can change the whole feeling of a vehicle or structure. Just remember to keep continuity between the components of your subject, a universal feeling that all the shapes still belong together.

The Original Image

Despite the roughness of the image, the proportions are pretty much spot on. Much time was spent getting the key lines, such as the edges of the windows and the shapes around the hood of the car and headlights right.

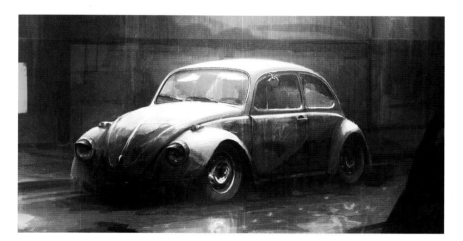

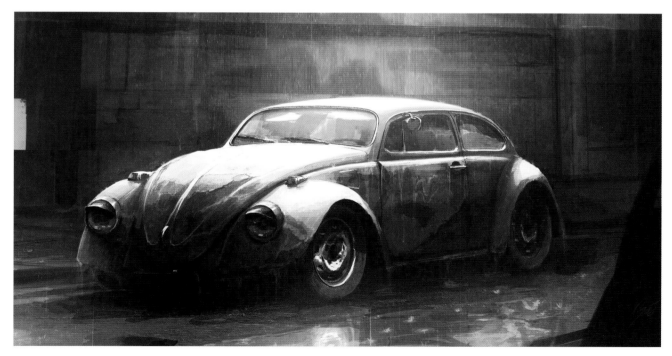

Altered Proportions

Notice the longer, slightly wider nose. The flattened roof gives the car a more sleek and slightly aggressive look. The rear wheel has been altered quite a bit to make it larger, giving the impression of a dragster type of vehicle that can travel very fast. It now looks more like a 1950s muscle car than a Volkswagen Beetle.

Place Scale Reference Objects in a Scene

If you are working on a complex and dynamic image, make sure there are some good scaling anchors in the scene to help the viewer understand the magnitude or diminutive nature of what you are depicting.

I used many good scaling references in this scene, but the human climber brings the scale of this piece into focus.

The immense city beneath the focal point makes it clear this is a large vista viewed from a high vantage point.

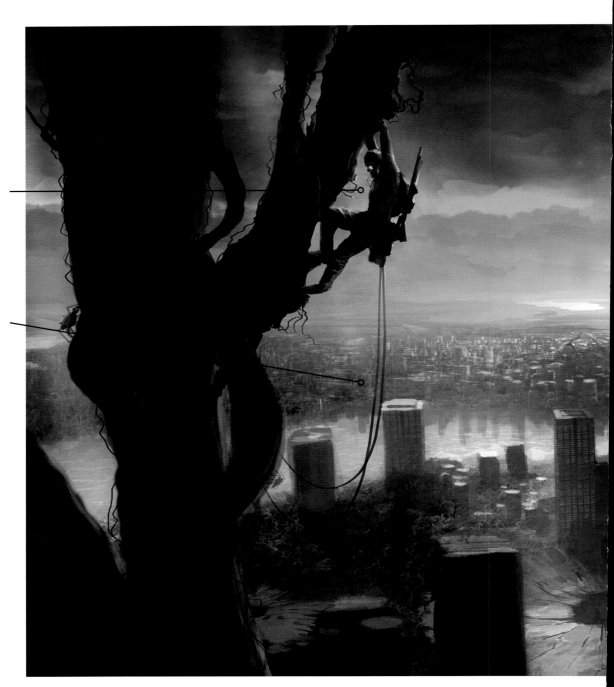

Sign up for our free newsletter at impact-books.com.

People and Creatures as Scale Anchors

Often the most effective method of establishing the scale of a scene is to drop a human in it. Our richest understanding of scale reference is our own size. Putting a human or humanoid creature in a scene creates the immediate understanding of how things are positioned and sized relative to us.

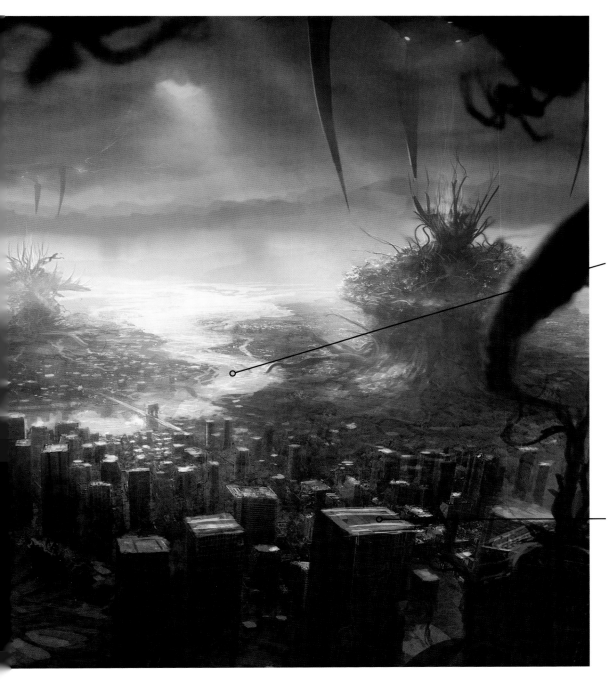

The river helps draw the eye towards the horizon and is a useful real-world scale reference along with the city.

The buildings are dwarfed by the enormous alien plant life, but these botanical leviathans still make sense due to the building reference objects.

Humans as Focal Scale Reference

For many artists, characters will always be the favored focal point of any image they create. In complicated images, such as action shots, balance the piece carefully to ensure that the character focal point allows the action to happen around him or her.

The drama of the flying car coming towards the viewer is very evident, so the woman in the corner establishes a sense of danger.

Focal Area
Here I veered away from the standard Rule of Thirds (see Chapter 5) for the positioning of the focal person.

Note the pinched and dramatic perspective of the woman.

Action Shot
This image is an excellent example of balancing an awkward pose and dynamic motion with some serious action in the distance.

Dramatic Scale Coherence

Drama is key to any truly exciting action image, but all of the very best images also have an attachment to the fundamentals of scaling and proportional balance. If you want to pull the viewer into your fantasy works, it is paramount that you push the limits of scale and depth to create new and exciting scenes. Just make sure that you stick by the following rules when you start to manipulate these elements. It does not have to be real, it just has to be believable:

- If you anchor scaling well enough, you can get away with almost anything.

- The rules of proportion are flexible—just keep things in proper relative proportion within each subject.

- The easiest scale reference for viewers to understand quickly is the human figure.

- The most striking vistas envelop viewers by the use of dramatic scale cues to create depth.

- Never miss an opportunity to underpin scale with real-world facets.

- Don't place a clumsily scaled object into a piece—the error can ruin all the efforts you have made.

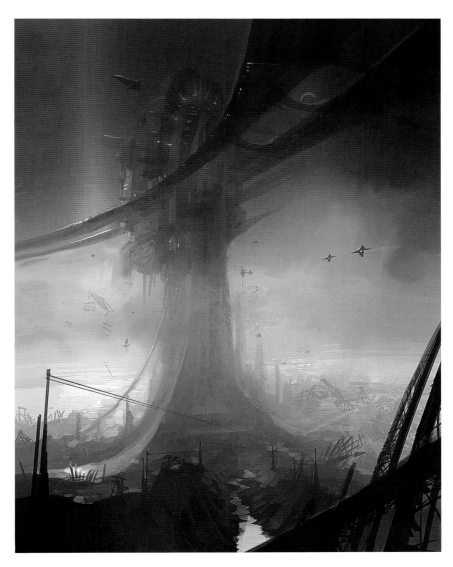

See the Scale, Feel the Depth
Here is a good example of really dramatic scale coherence. The atmospheric depth, exaggerated perspective and contrasts of scale all contribute to the image's success.

LAYERS

I remember the day I found out that layers had been introduced in Photoshop—it totally revolutionized the program. For the first time I could create complex compositions easily, without having to deal with the less intuitive channels feature or jump through a load of hoops to create separate painting surfaces. Before layers, if you wanted to make alterations to illustrations, or even do something as simple as change a font, you were in for a world of pain. By comparison, I think it is fair to say that layers are absolutely fantastic.

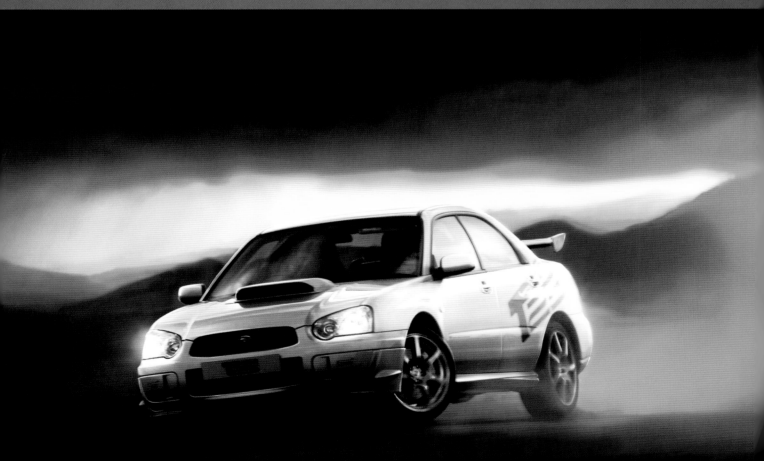

What Are Layers? Why Are They Useful?

A layer is simply one image stacked on top of another. It's like drawing on a piece of paper (the background), then dropping a clear sheet on top of the background to add a layer. You can then paint on it without damaging or altering the background. Each new layer is like another transparent sheet. The beauty is that you can add as many layers as you like.

The Simple Image
This first image shows a gray gradient background and a pale blue rectangle with a string of text on it.

The Layers Palette
The Layers palette for this image shows there is a background layer (the gray gradient), a layer with the blue rectangle and a layer with text.

Dramatization
In both images the text layer is floating on top of the blue rectangle layer, and the blue rectangle is floating on top of the gray gradient layer.

Add Layers to Try New Ideas

Layers allow you try new ideas and be braver about experimenting on your pieces. Imagine you want to paint in some different decals on the car in the image below. If this were done on a flat image, it could be tricky and time consuming. With layers, however, you can experiment quickly and easily.

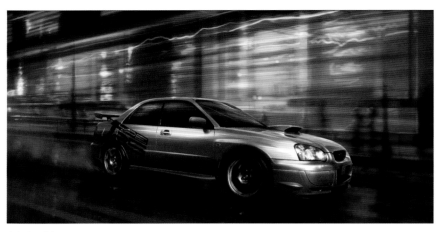

Original Image

If this were a traditional painting, you might be hesitant to tweak parts of it or add new features. However, you can safely experiment by creating a new layer. If the changes don't work out, the original image is intact underneath.

Decal Layer

I pasted the decal into the image, then changed the mode of the decal layer to *Hard Light* to achieve a shiny, semi-transparent effect.

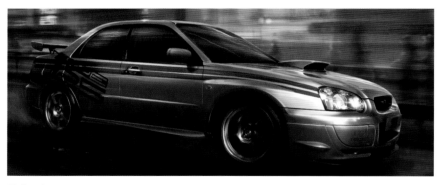

Stripe Layer

Two parallel lines tracking the length of the car were created with the polygonal lasso tool. The selected area was colored in with different shades of gray, and this layer was then changed to Hard Light mode. The end result is a slightly polished looking set of dark gray decals across the car. They're on a layer, so can easily be deleted, hidden or tweaked without harming the illustration.

Altering the Stripe Layer

The line colors were tweaked to a bright red using the Hue and Saturation adjustment. You can also make a duplicate of the new layer and do alterations on that, resulting in an illustration on the bottom with two layers above—each with differently styled decal lines. Switch between the two versions by clicking the "eye" buttons in the layers palette.

Intermediate

Various Layer Options

To take full advantage of all layers can do, it helps to learn the options for controlling and altering their effects. With practice, you will find these very useful.

- **Shifting Layer Contents**

 To shift a layer's contents around freely, click and drag with the Move tool (the black arrow). To constrain the direction of movement to up/down, left/right or diagonal, hold down the SHIFT key while dragging.

- **Naming Layers**

 It can be difficult to keep track of what is on each layer

when using default names like Layer 1. Change the name of a layer by opening the layers palette, right-clicking on the layer and selecting Layer Properties. This brings up a dialog box allowing you to rename the layer and even change the color of the layer box—helpful for multiple layers in a piece. You can also double-click on the text of the layer name and type a new name.

- **Showing and Hiding Layers**

 There will be occasions when you have layers in your piece you do not want to see (perspective line layers for instance). You can quickly toggle a layer on or off by clicking on the eye button in the layers palette.

Layer Modes
Click here to change the way a layer behaves. This brings up a menu with options for different layer modes.

Opacity
Altering this number changes the master opacity of the layer and any effects connected to it—useful for lessening the effect a layer has over what is beneath it.

Fill
Altering this setting changes the opacity of the current layer but not the settings and strength of the layer effects. This allows you to tweak the impact of the pixels on a layer while keeping the effects at the same intensity.

Lock Transparent Pixels
Use this to paint on a layer without changing the borders of what is already established, or increasing or reducing the opacity setting.

Lock Image Pixels
This option locks the pixels in a layer. The layer can still be moved, but not edited.

Locking Position
Use this to lock movement of a layer. You can still paint on the layer but don't have to worry about accidentally moving it.

Lock All
This option disables all editing. You cannot paint, move or alter the opacity of a layer when this option is set—useful if you are happy with a layer and want to protect it.

Efficiency With Layers

The drive to add new layers while preserving what you have already created will be powerful, but there are a few things to be aware of when working with layers.

- **Layers Use Memory**

 Layers can eat a lot of memory, especially on large or complicated pieces. This may slow down your computer and fill your hard drive with enormous files.

- **Navigating Layers Can Be Confusing**

 Navigating lots of layers and remembering exactly where you are can be confusing. There will be times when it makes sense to keep important or radical ideas separated, but label the layers well so you don't accidentally start painting on the wrong one.

- **Control Layer Numbers**

 Save sequential files at certain points. If you reach a point where you feel the layers are getting out of control, or if you make a breakthrough with a piece, flatten as many layers as possible and save a new file. The old file still has the original layers, and the new one is flattened and easier to edit.

- **Excessive Layers Can Stifle Creativity**

 Flattening layers not only frees memory and speeds up the computer, it frees you up to carry on painting. If you allow layers to take over your workflow, you end up bouncing from one layer to another and can become afraid to commit to your art. Remember you are painting, not creating a tower of layers!

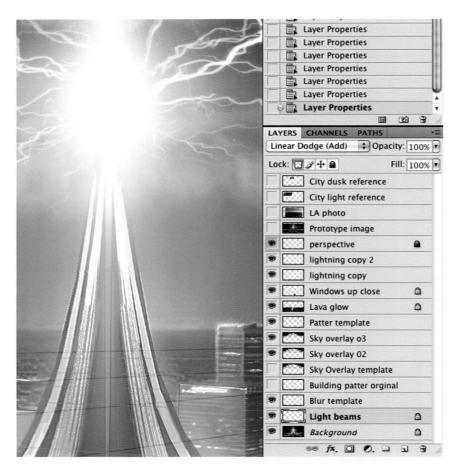

Control Layers for Efficiency

Too many layers can stifle creativity and burn up memory on your hard drive. Label layers well for easy navigation. Flatten as many layers as possible and save a new version of the file to increase efficiency.

Using Layers as Masking Tools

Masking can be a great tool, but for illustration purposes, layers offer greater flexibility in editing a piece. Working in layers enables you to be constantly dynamic, tinkering and experimenting with separate layers until you are happy with the overall composite. Once you are happy, simply flatten the layers and save.

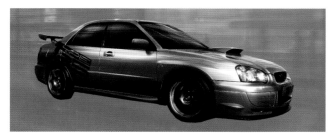

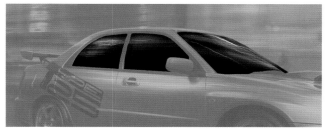

Create Protected Areas on Separate Layers
Using the polygonal lasso tool, the car shape was copied and pasted from the background. The background was then re-selected, and the windows were copied and pasted onto another layer. The image now has a background layer (original image) and two other layers, each with a different cutout of the car.

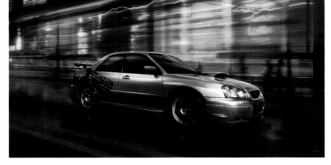

Layers Palette
Because the elements of the image are on separate layers, each one can be tweaked and transformed without affecting the others. (The gray inter layer was added to clarify this demonstration; it was not used in the actual piece.)

Background Change
Changing the background to a steely blue tone did not affect the car at all.

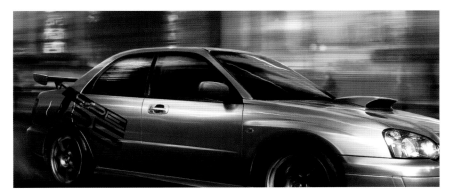

Alter Layers Independently
This closed-in crop shows how I altered the contrast of the windows. Again, the car layer below and the background were not affected.

Adjustment and Fill Layers

Two useful features in more recent versions of Photoshop are adjustment layers and fill layers, which make it possible to add a variety of controllable effects to underlying layers. Effects such as Brightness/Contrast, Hue/ Saturation, Channel Mixing and Color Balance can be placed onto these separate layers, as well as solid colors, gradients and patterns. A key advantage is having the ability to overlay effects onto your piece without having to bake them onto the image, so you can keep changing effects until you are happy.

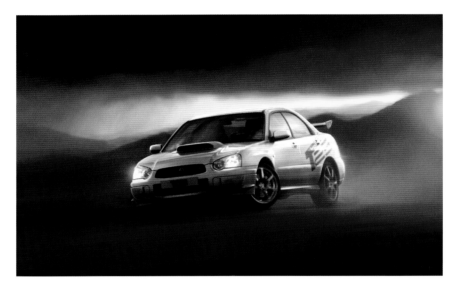

Original Image
Imagine you want to try out some different color effects on this image without baking them onto the file.

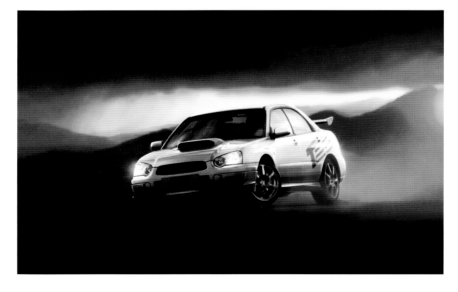

Altered Image
The image now has more contrast and a cooler, bluer hue, particularly towards the darker tones. Adjustment layers allow you to finesse and experiment with effects like this up to the point when you flatten the layers back onto the pixel canvas below.

Adjustment Layers

Creating adjustment layers for Brightness/Contrast and Color Balance allows you to tweak the values as much as you like and see the effects without having to commit to them. (Please note: The pink overlay has been placed for clarity and is not part of the original screen shot.)

Brightness/Contrast

I used one adjustment layer to increase the brightness and contrast.

Color Balance

I tweaked the color balance on another adjustment layer. Settings shown here are for the midtones in the image.

Apply and Adjust Layer Styles

Adjustable effects and styles can be useful for achieving quick special effects such as drop shadows and glows. There are many settings and combinations you can apply using the layer style modes.

1 START WITH THE ORIGINAL IMAGE

The original image consists of a gray gradient background and two layers on top—one with shapes and a text layer with numbers.

2 ADD LAYER WITH GLOW AND DROP SHADOW

Select the desired layer in the layers palette, then choose Layer > Layer Style > Blending Options. For the shapes in this illustration, I created a bluish outer glow and a gray drop shadow.

3 ADD DROP SHADOW, INNER GLOW AND BEVEL

Add a gray drop shadow, an inner glow (set to a deep orange in Linear Dodge mode) and an inner bevel to the text layer.

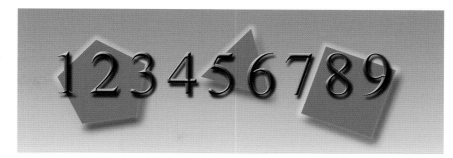

4 VIEW AND TOGGLE STYLES USING THE LAYERS PALETTE

An "fx" symbol in the layers palette indicates that styles have been added to the layer. Click the triangle for an expanded view with show/hide buttons that you can use to toggle individual layer styles on and off.

Paint on Separate Layers

Painting special effects onto a piece or adding brushstrokes with special brush modes (such as Dodge) can be quite daunting because it has an impact on the canvas underneath. It is possible to set up layers, however, so you can paint in the style you want on a separate layer.

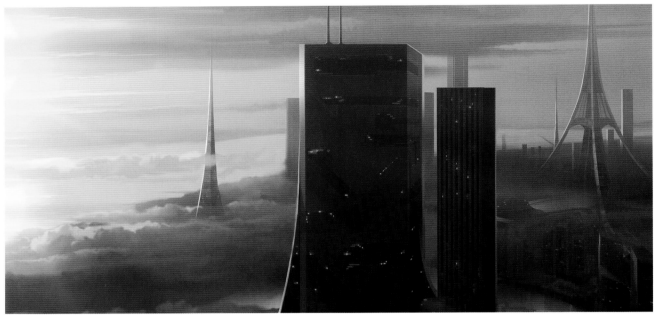

1 Start With the Original Image
Start with a crop from an existing image. The buildings have some subtle lighting effects that simulate windows and other shapes. Now imagine you want to experiment with additional lights but not lose the integrity of what is already there.

2 Create a New Layer in Linear dodge Mode
Create a new layer and change its blend setting from Normal to Linear Dodge. (Please note: The pink overlay has been placed for clarity and is not part of the original screen shot.)

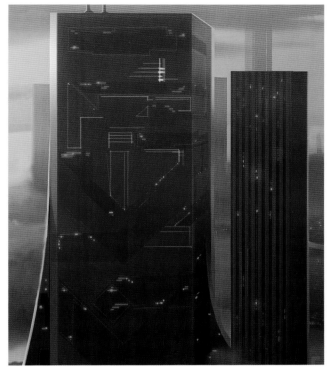

3 ADD BRUSHSTROKES TO THE NEW LAYER

On this new layer, start painting on top of the original building. The brushstrokes you add will automatically have the Linear Dodge effect applied to them because it is encoded into the new layer.

4 CHECK YOUR WORK OVER A BLACK BACKGROUND

To see the glowing effect in action, temporarily put a layer of black underneath the Linear Dodge layer.

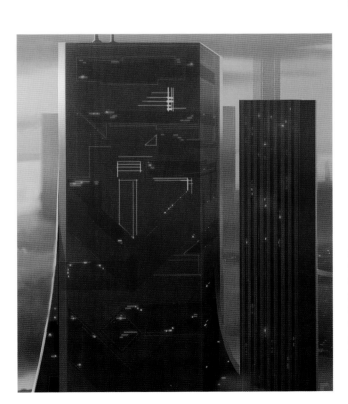

5 TWEAK AWAY!

Tweak the new lines as much as you like. (Remember they are on a separate layer.) For this image, you could use a Hue and Saturation pass to change the color of the new lines and get a more orange-red look. Or you could lower the opacity of this layer until you achieve the balance you want. Painting in this manner gives you both versatility and the confidence to try different effects.

LOW-DETAIL PAINTING

One of the most fascinating things about art is how diverse "finished" illustrations can be, both in finesse and in detail. In this chapter you'll explore low-detail painting, the process of painting quickly and loosely without many details.

You may be surprised at the amazing imagery that can be achieved with low-detail painting, and there is much to learn by working loosely. Painting images that are not intended to be perfect is a valuable process. You should come away from this chapter knowing that art is not always about perfection, but rather about perfecting your expression. Learning to paint more quickly and with less stress is a path to the stronger artist in you.

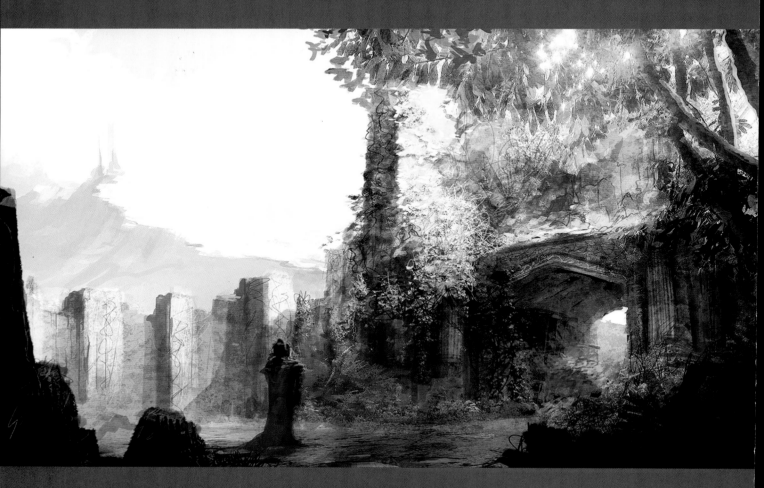

Fundamentals of Low-Detail Painting

Do not assume that spending more time on a piece of art is a certain way to make it wonderful. There are good ideas and bad ideas in art; some ideas are destined for greatness and some are not. If you approach your art in this way, you'll realize that your creative input is a resource to respect, so you may not want to spend 50 hours detailing an image that is not working out very well. This is where the wonders of low-detail painting, also known as sketching, show their value.

If you have roughly painted out your idea, you'll know whether the idea will work before you even start the process of detailing. If the idea does not turn out, you can quickly try a different angle or composition for the same image, or quit and start fresh without losing hours of your time.

Painting loosely is also a good way to strengthen your skills as an illustrator. Testing your ideas out with fast brush-strokes hones your skills with the tablet and pen. The ideal lines you had for the image in your head might be beaten by some fresh and free lines you lay down as you paint instinctively.

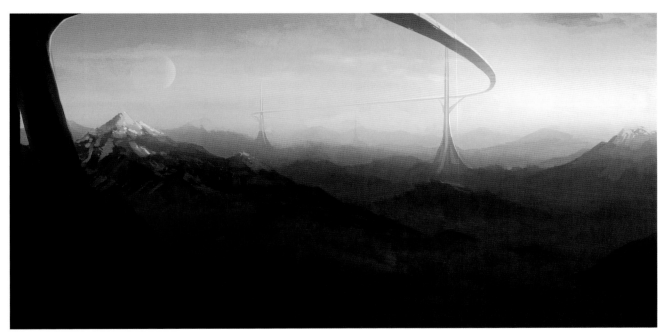

When Less Is More

This image was created in about 75 minutes and is all the better for it. It simply did not need any further work done to convey what it needed to.

Noise and Texture Bring Images to Life

It is possible to create an excellent illusion of detail without spending the time to create detail explicitly. Using texture, image noise and interesting brushstrokes will allow you to create a compelling image that looks much more detailed than it actually is. If you create something that feels cohesive without being too explicit, you can capture the imagination of people in diverse ways.

There is a feeling of moving from warm to cold, light to dark and life to death. The vague color differences from warm on the left to cooler on the right allow the viewer to decide what is happening.

Light bouncing off of surfaces like the helmet is painted in a loose way so the viewer can decide what the shapes and light are doing.

Lighting, organic shapes and judicious use of greens and blue-greens imply that the knight is surrounded by fauna and trees without the need for laborious detail.

The knight is wearing shiny ornate armor and a flowing red cape. Or is he? The low detail and abstract nature of the painting create this impression in the viewer's mind.

Keep It Loose—Let the Viewer Fill In Details
This piece was painted with just a few stylized brushes and some loose brushstrokes. It is a study of form, color and light, but nothing is explicit. It allows the viewer to build up what is in the piece from the implied details.

What Can You Achieve By Sketching?

It's not possible to literally show you how to find your own style of loose painting, but there is no shortage of excellent reasons to work on your sketching skills and push yourself to become more confident with them.

Draw loosely in the ways you are most comfortable, but always look towards pushing yourself out of your comfort zone into new ways of creation.

Sketching Is Rewarding

Painting loosely is a speedy process so you can quickly arrive at a point of knowing if an image is finished or should be abandoned. You'll also quickly see if something potentially greater in the piece worth working on. The turnaround is so fast, you won't have to worry about getting into an artistic rut—there will be no time for that! Low-detail painting also avoids the expectations of a full illustration, which can it make it more fun. (And you'll be surprised at what you might achieve when you're having fun!)

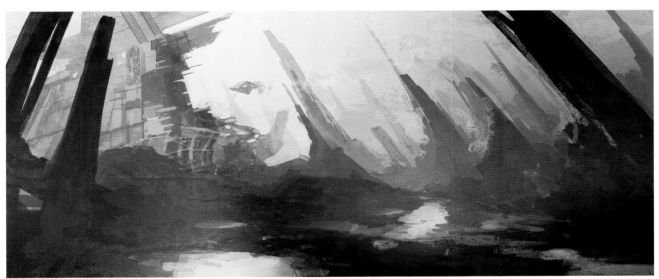

Sketching Forms a Foundation for Greater Things

Very few great images are created without substantial trial and error. Loosely test out your ideas first, and only take the image forward if you see that flash of inspiration and brilliance in the piece. You'll find that your final images are more satisfying if you do. Think of your sketches as the ground you will build your painting on—you want that ground to be as sturdy as possible.

Through this process, you'll also find that your painting style and artistic skills greatly improve. You'll become more confident in creating image ideas quickly when you've built up a range of personal art techniques of your own that will seem like magic to others.

Intermediate

Understanding Stroke Efficiency

In artistic terms, stroke efficiency means the number of brushstrokes used to complete an image and the level of confidence in applying them. It is a good measure of your assurance as an artist. Bold and strong key lines show the viewer that you knew exactly what you were doing when you laid those lines down. Even in the case of abstract images, the viewer can still see the level of confidence in the strokes used. Practicing your sketching skills will augment this.

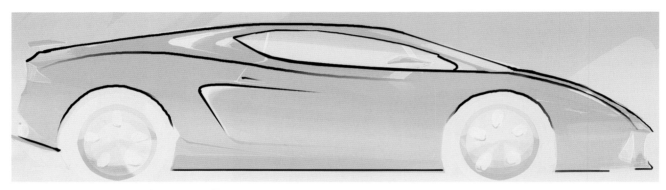

Key Lines Are Paramount in Low Detail

When creating a low-detail image, the key lines (in this case the lines establishing the car's shape) must be strong and confident. While these lines are not necessarily used in a rough and textured image, the viewer must be able to tell what the subject is no matter how loose the image. Areas outside of key lines can be treated with a less-detailed approach. As long as the key lines display integrity, the areas between them will work fine.

Single-Stroke Efficiency

The lines establishing the shape of the character in this piece are of a single-stroke nature, giving the impression that they were all deliberate and no more brushstrokes were used than necessary. Notice that although the face has little detail to it, the viewer is able to build up an idea of how the character looks—based on nothing more than a few simple brushstrokes.

When dealing with areas you don't want to focus on, a softer brushstroke pattern is required. Very little relative detail was used in the background, which helps the viewer focus on the more detailed (though still not particularly high-detailed) character.

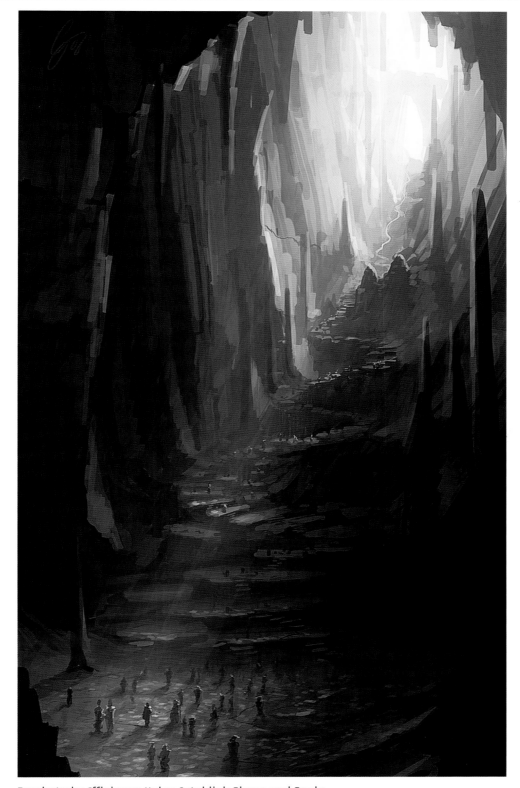

Brushstroke Efficiency Helps Establish Shape and Scale

This image illustrates some good examples of brushstroke efficiency, such as the stalagmites and stalactites, which help establish shape. However, there are very few dark strokes or highlights.

The shapes of the people climbing the stairs are also good examples of stroke efficiency. While the viewer can easily recognize the silhouetted people, they were created with just a few simple and confident brushstrokes to help establish shape and scale against the background.

Use Texture to Create the Illusion of Detail

One of the best things about painting in low detail is the fun you can have experimenting with and thinking up ways to show diverse features and objects without spending the time to paint every single facet of them. Here you'll explore how to apply a rough texture to imply details and give a lovely impressionist look.

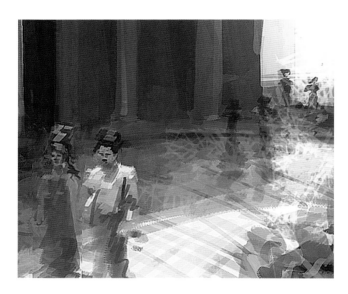

1 CONSIDER SUBSTITUTES FOR DETAIL

Use a block-shaped brush with jagged edges to create very simple people. This gives the impression of movement as they walk through the atrium. Use a scatter brush in the distance. This is a random-direction line brush (similar to the one described in Chapter 1) stroked over the image with a low opacity.

2 DETAIL KEY ELEMENTS

Add slightly more explicit detail to a couple of the key shapes, such as these arches. Use a fairly steady hand to draw lines that make up the framework of the image, like the glass roof here. Be careful not to make it too accurate, however. You don't want tight patterns to clash too much against the rough texture.

3 ADD ORGANIC ELEMENTS

Flora may be represented by nothing more than some wild brush-strokes with varied opacity and color. The randomness of these particular facets makes them appear more organic than the already loose architecture. Remember to always paint flora softer, more asymmetrical and more random than man-made structures.

4 ADD REFLECTIONS AND SHADOWS

For abstract images, make reflections with just small dabs of paint to represent reflected colors. On a loose and textured image such as this, it works very well and there is no need to go further. Make shadows loose and abstract as well to keep the lighting in the same style as the material texturing.

5 REFINE DEPTH AND LIGHT

Add a simple color wash of a light yellowish tone over the mid distance using the Lighten layer mode. This helps drop the back of the room away from the closer parts. The impression of warm sunshine cascading into the atrium helps solidify the piece. No matter how loosely you paint, there should always be elements that are believable and physically correct—light and shadow are two facets you'll want to get right.

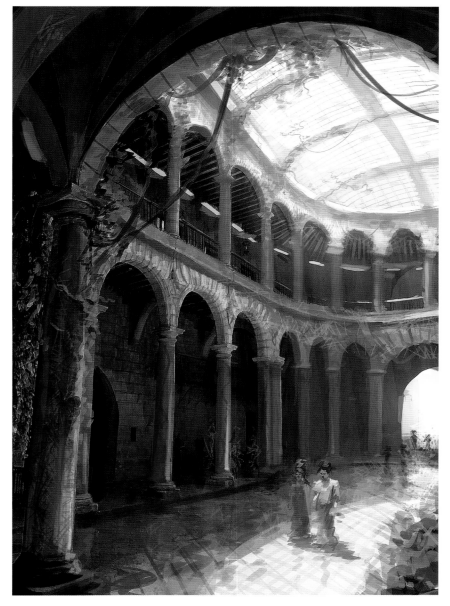

Movement, Dynamism and Anarchy

There is much you can do to give life and drama to low-detail images, especially if you want to imply a feeling of speed and movement.

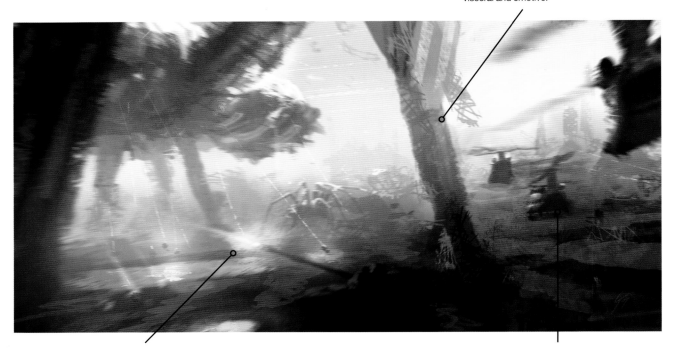

Note the fierce use of loose brushstrokes and patterns. The image is intended to be visceral and emotive.

The use of explosions and the muzzle flashes of the tanks on the ground notch up the drama and movement. High velocity objects like missiles and bullets inspires the feeling of anarchy.

The slight tilt on the camera furthers the feeling of movement. Never underestimate this effect.

There is no focus on any particular detail, resulting in slight visual confusion. However, the strong silhouetted shapes keep the viewer focused inside the piece and the blurred helicopters lead the eye towards the enormous spider mechanics.

Motion Blur

I used a Photoshop filter called Motion Blur across the whole image. It creates visual movement that allows the viewer to experience a sense of dynamism. To achieve this subtle effect, an angle of 8° and a distance (blur amount) of 12 pixels were used.

Back to Basics

No matter how rough you decide to make your low-detail sketch or painting, always maintain good coherence with the key shapes and composition of the piece. Also, maintain a believable and well-solved lighting setup.

You can play with texturing an object all you like, but you must ensure the subject you are stylizing is still identifiable. Study the following guidelines for keeping an image readable.

Light, Shadow and Depth

Light and shadow help place everything in scene properly. You can get away with using very little detail if you get the lighting right. Lighting can be anything you want it to be, but remember it's key to understanding the scene. Use a chaotic style if you like, but keep it coherent.

Even if an image is rough, depth and distance help the viewer read and appreciate the piece.

Scale and Proportion

Scaling coherence is also important, as are proportions. Never neglect these elements; just because you're working loosely doesn't mean that your scaling and proportions can be off.

Tie It All Together

Although this low-detail image took just eight minutes to paint, adhering to the rules of keeping what is on the image readable keeps it interesting. Despite their crude nature, the misty hills, spacecraft and tower are all readable because of proper scale, depth and shape.

Create a Low-Detail Painting

Create a simple speed painting. When painting quickly, it helps to use blocks of color as foundations, but you don't have to. Use your own style—whether that means drawing lines first and then painting, or simply setting down tones. The key is to emancipate yourself—paint fast and free.

1 APPLY A COLOR WASH AND ADD SIMPLE SHAPES

Add a color wash to the image. I used a fairly soft and subdued muddy green color. This is the foundation of the painting so as you add more detail, expect to adjust the overall brightness and contrast of the piece.

Once you have the wash in place, start adding some simple shapes to help establish the image you plan to depict. Here, some rough shapes represent jagged rocks.

2 ESTABLISH GROUND LEVEL

Once the basic abstract shapes are in place, establish the ground level (something for the rocks to be jutting out of). It's always a good idea to depict diverse materials—in this case it's water. Roughly paint the water as nothing more than a slightly lighter set of green tones wriggling their way into the distance.

3 ADD A FOCAL POINT

Place the focal point in this image dead center horizontally, but in the top third of the image vertically. Use some more simple green tones to quickly paint an organic, vertical tower where the water reaches the misted-out horizon. The tower will provide a sense of scale.

4 CREATE DEPTH AND ATMOSPHERE

Use a combination of soft brushes and the smudge tool to add a cloud layer above the background. Create a new layer for the clouds temporarily to allow yourself to play with the colors, shapes and opacity of these elements without affecting what you've already painted. Once the clouds are right, flatten the image and spend some time playing with the overall contrast. Add some light details to the tower and ground.

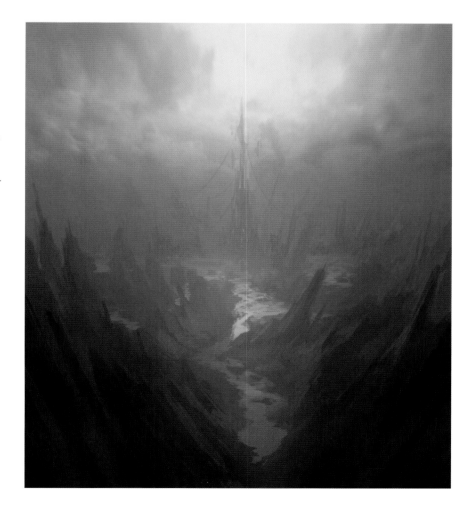

5 ADD SUBTLE HIGHLIGHTS TO THE ROCKS

Using simple brushstrokes, add subtle highlights over the top of the dark shapes of the jutting rocks. This gives the rocks a solidity and also helps give the viewer an understanding that despite the foggy conditions, there is a gentle light coming down from above.

6 ADD THE CRAFT FOR SCALE

Paint a couple of smaller objects closer to the viewer to reinforce the scale of what is further away. With this particular craft, I used Photoshop filtering to achieve a flying feel.

Here a layer was created and the Junker-type craft was painted on it. The area around the craft was selected, and the Radial Blur filter was used to create some motion blur emanating from the general direction of the focal tower. This motion blur really helps sell the craft as a flying object.

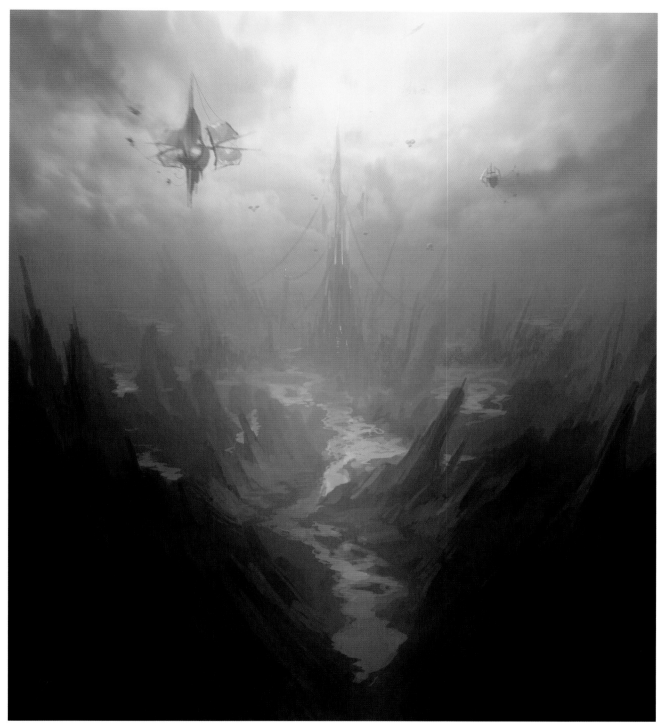

7 ADJUST BRIGHTNESS AND CONTRAST

Do a quick Brightness and Contrast pass over the image to give it more kick. (Here the contrast and brightness were upped about 10 percent.)

The final result is a piece with an interesting, slightly dirty feel to it. A few color washes and some subtle brushstrokes have produced a nice deep image. Remember, you do not need to be explicit and detailed to compel the viewer.

HIGH-DETAIL PAINTING

Painting in high detail is the pinnacle for many artists. While it takes substantial time and effort to create a full-fledged and detailed illustration, the rewards can be immense. A detailed image can be blown up and printed in large scale, or used for film and TV work and promotional art. Plus, it's always nice to sit back and admire all the work and detailing you have put into a piece.

　　If you follow the tips in the rest of this book, particularly those that address how to sketch and paint ideas quickly in low detail (Chapter 9), then when you decide to create a high-detail image you will already have thought through all your options and increased your chances of success.

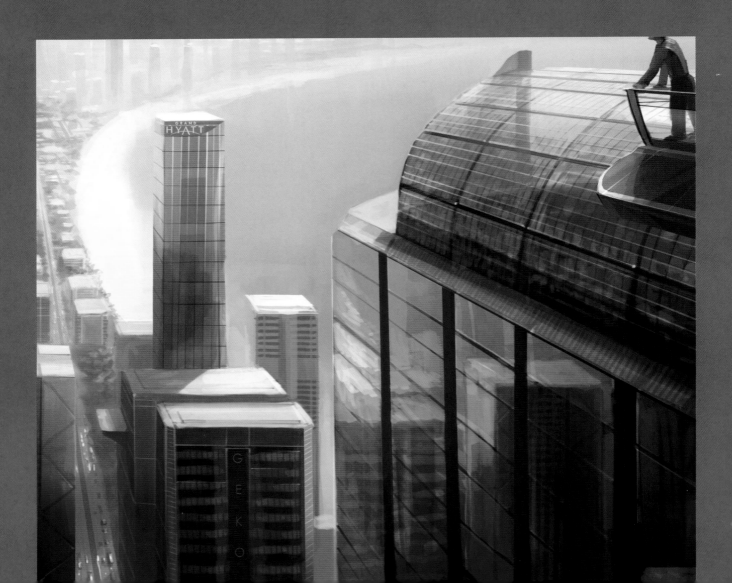

Strive for Draftsmanship

There are few shortcuts to achieving greatness at anything. Art is no exception, even in the digital realm. Imitating and learning from other art styles is part of the process, but as an artist you'll be much more defined, refined and respected when you learn how to interpret real life and fantasy on your own. It is well worth spending the time and effort to practice and improve your abilities in rendering proportion, scale, line integrity, color theory, lighting, materials, composition, stroke efficiency and confidence. Art is a continuous learning process. Strive to develop your own style of creating.

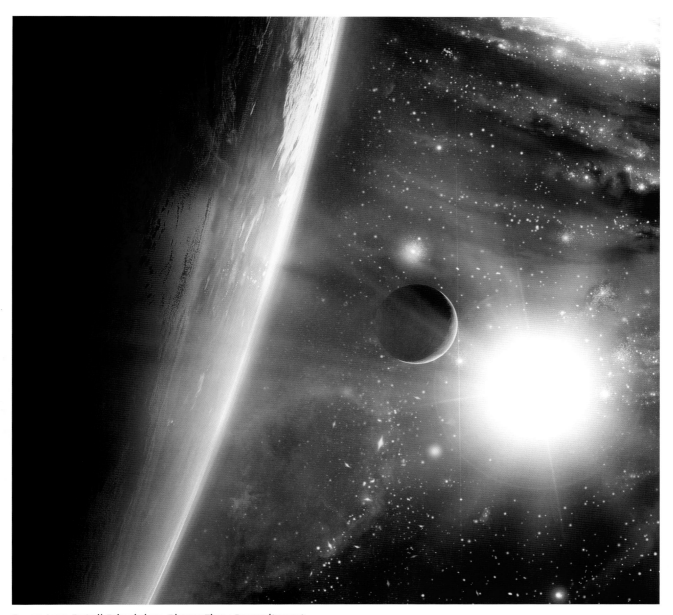

Same Low-Detail Principles, Bigger Time Commitment
This image involved a lot of work, but the principles I applied are the same ones I would use for a less detailed piece of art. It just requires more time to fill in the details.

High Precision With Digital Tools

It's much easier to create accurate images when painting digitally than when using traditional media. The sheer number of options and tools at your disposal allow you to better control your brushstrokes and colors, protect the painting at a touch of a button, experiment with new ideas quickly and have the freedom to modify and tweak details freely.

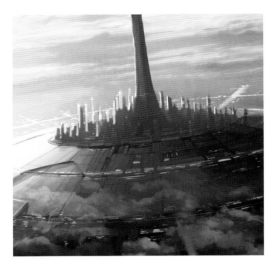

Accurate Shapes and Sharp Edges

Create a temporary layer and use the polygonal lasso tool to select the area you want to paint. Paint that area in any color or effect you like, or scale and adjust the new shape. The tower and small structures in this image could be safely painted this way.

Clear Lines

Use the Line tool to create sharp lines like the ones in this image. You can also use the SHIFT-click with the brush tool to draw a line from where you last painted to where you have just clicked.

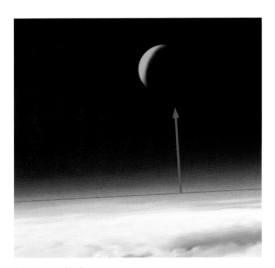

Smooth Interpolations

Create interpolated, or smooth transitioning, colors and effects with standard Photoshop soft and round brush settings in the correct blend mode. The atmosphere here was created with a 500-pixel round brush in Lighten mode at 40 percent opacity. A medium blue tone was applied to the horizon until there was a smooth edge in the dark space above the planet.

Gentle and Precise Brushwork

I created a new layer for the clouds over the background planet. The basic shapes of the clouds were formed using soft 30- to 40-pixel brushes and careful brushstrokes. Photographic reference was brought in on a separate layer. The smudge tool was used to gently push the newly laid brushstrokes and produce a mottled, softened cloud.

Understanding Where to Use Details

Working in high detail is not about adding the same density of work to every part of an illustration. It is better to think of it simply as refining your image to a greater level. You always have the flexibility to alter the level of detail in your piece, but no matter what you do, you must keep the image cohesive. It is fine to have small areas of lower detail, but the quality and integrity of your brushstrokes must be closely equalized.

High Detail
The complex clouds and the planet in the distance are heavily detailed. However, they are slightly lower in detail than the main focal points.

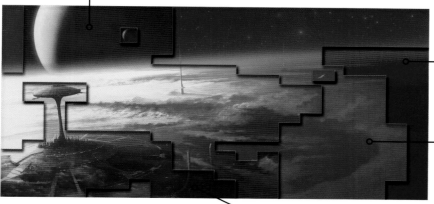

Low Detail
The far right of the image has less detail— note the progressively less complex cloud painting. Lower light levels here also allow for fewer details.

Medium Detail
The areas towards the right of the piece and the star field did not require the same level of detailing as the focal areas. Coherence in quality with the rest of the piece is still very important.

Application of Detail
Here is a breakdown of where detail was applied to the finished image.

Maximum Detail
The red area covering the spaceport, ground-level city and other surrounding areas received full-detail treatment. The need for lights and structure required diligence and patience with detailing.

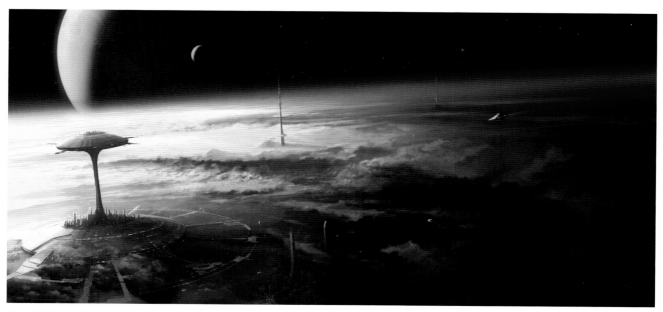

The Finished Piece

Exacting Detail

In creating art for advertising, print or film work, there is flexibility for interesting style and visual interpretation. However some things, such as accuracy of the subject's shape and proportions cannot be compromised.

The abstracted and blurred surroundings reinforce the important lines established for the focal point, drawing the viewer's eye to the perfection of the subject and how it stands out from the imperfection all around it.

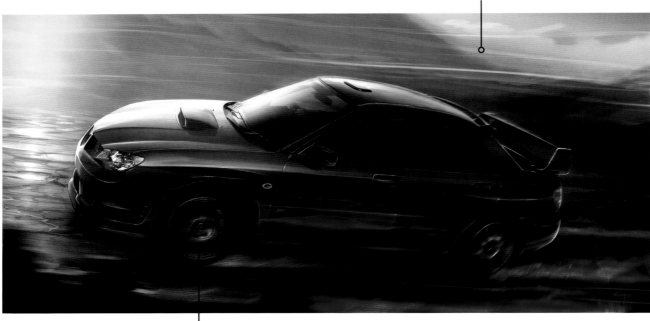

The front wheel, though spinning and blurred, adheres to the shape of the outer rim, while the back wheel has a more blurred feel across the whole area around it. Because the wheel shape was anchored with the front wheel, the viewer will read the back wheel to be the same as the front wheel.

Exact Proportions, Augmented Details

All the varied parts of the subject must be in the right place and at the correct scale. In engineering, proportions are exact, and accuracy in representing them is important. It is possible to offer a new and idealistic look that has elements of super-realism or exaggeration, but in the complementary sense. A good example of this is the larger wheels and lower profile tires used here which, realistically, would be impractical.

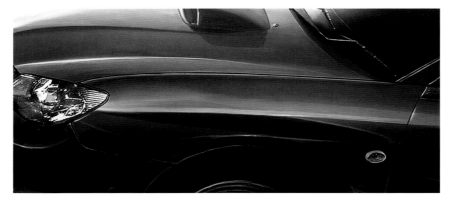

Where to Focus Details

The key ingredient to a successful complementary piece is identifying and augmenting the best qualities of a subject, while understating the less endearing features. Take everything in, but always push forward the best parts.

Much time was spent amplifying the striking lines towards the front of this car and lessening the focus on the rear.

Implied or Painted Detail

The thought of painting a fully detailed, high-resolution painting can be a daunting prospect. However, it is not always necessary to paint everything. On many occasions, working detail into one area will reduce the need for it in another.

The craters on the planet's surface warrant a higher degree of detail with strong light and shadow.

The crescent lighting across the planet requires quite a lot of detailing. Neglecting areas like this will lower viewer interest.

The sun here is a great secondary focal point, and it needs only tones of a gradient to draw in the viewer's eye. Where there is brightness, there is little need for detail.

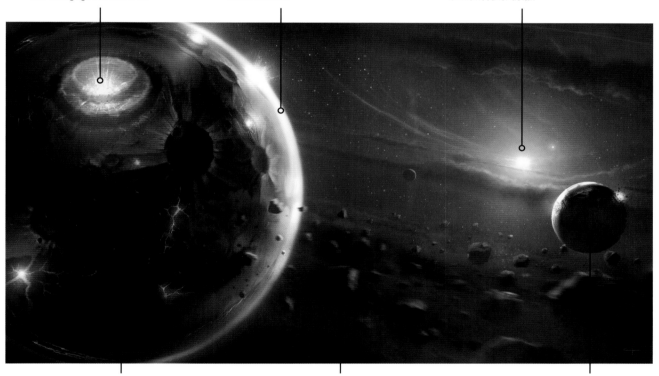

The unlit darker parts of the planet naturally have less detail. As long as the shapes are coherent, you can leave these areas largely alone.

Up-close, silhouetted moving shapes require a cursory level of lighting and detail. For these shapes, a motion blur renders detail even less important.

The moon needs some detailing so the viewer can recognize its composition.

Avoid Overworking an Image

Here are some good reasons not to overwork a piece of art:

- Detail in the wrong place will distract the viewer from your intended focal point.

- The wrong type of detail can work against the mood or message you are trying to create. (Think carefully before spending twenty hours painting flowers into the background of a car illustration, for example.)

- Every painting reaches a point beyond which adding more detail will not add any more meaning to the piece. Sometimes an image reaches its peak long before the amount of detail reaches its maximum.

Areas of tight detail and clarity but also areas of very little detail, relying on blocks of color and simple brushstrokes. Note the strong key lines.

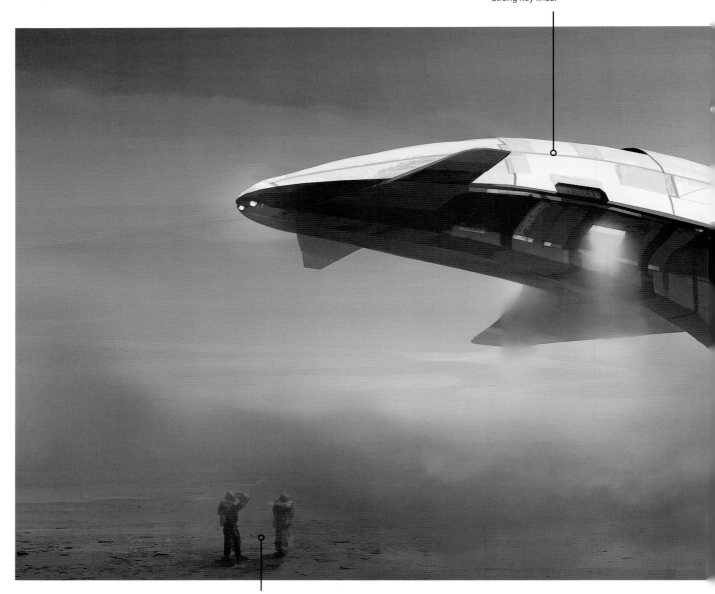

This image is about the craft, not the people, so only a sketch level of detail is needed for the figures.

Embrace Your Creative Process

You have your own artistic abilities and more importantly, you have your own way of seeing the world and translating that into a creative project. The most profound art manages to be not only new but also individual. There will be times when you become frustrated with the artistic process, but always remember that your personal creative process tells a story about who you are as an artist. Embrace it!

Simple crescents for the moons—no need for much more detail.

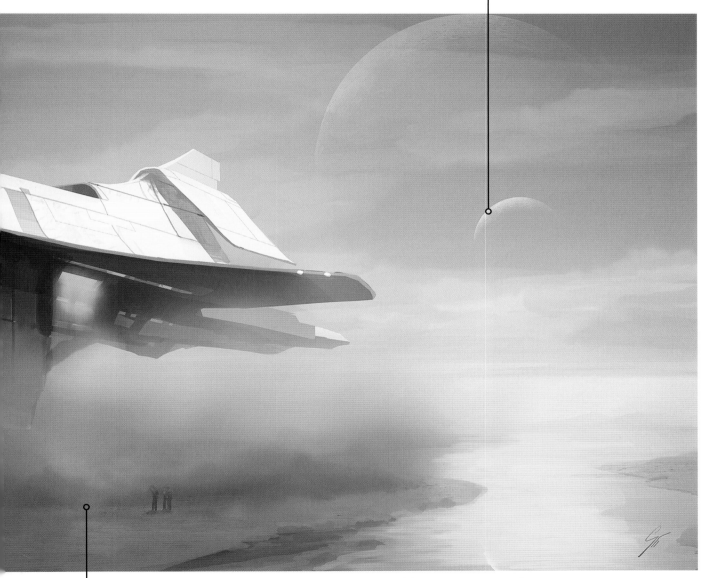

Loose painting of sand and dust being shifted by the thrust of the hovering craft. Soft, simple brush-strokes were used to create the dust clouds.

Avoid Unnecessary Details

Detail takes time to create. Spend that time wisely. Don't add what won't be appreciated.

High-Detail Shading and Highlights

When working with detailed, high-quality images, you're committing to a lot of time spent tweaking and finalizing a piece. So when you start finessing areas of an image with high-quality shading, it's important to know what you're doing. Take your time and get into a groove of enjoying the effort you're making.

Reference is key. If you want to render an image containing shiny, painted bodywork, for example, you need to understand how and why that surface behaves the way it does. Take photographs of real surfaces that are similar to what you want to create, or look for stock photos on the Internet.

Once you have your reference, experiment with painting a surface. If you are building your own high-detail style, play with ways of taking what makes materials and highlights look real and transform them into styled personal versions of the same thing.

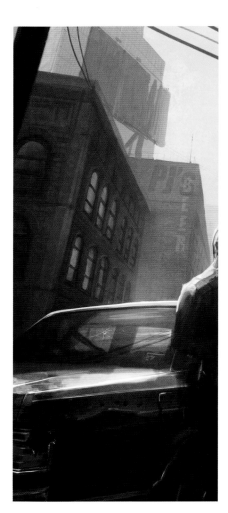

Focus on Details

With highly reflective subjects, detailing is what counts. Take in the nuances of how paint behaves across a smooth wide surface as well as on a rolled or sharp edge. Observe how it reflects, and how it looks in bright light and shadow. The more you study and understand these materials, the better you'll be able to translate them.

Diverse Materials

This image crop shows the integration of a shiny surface into a scene with a number of matte materials. The interplay of these diverse surfaces and their cohesive style is key to the viewer reading the image properly. The surfaces all have a very defined drawn style, but their physical behavior still mirrors realism.

Keep Images Alive and Avoid Sterility

In the effort to finesse and improve your painting skills, there is a potential danger that you could end up with an image that is too clean and, possibly, a little dull. Here are some ways to keep your images from becoming sterile.

Add Weathering Effects

Even in the most high-quality images, there is room to show some wear and tear. Small, well-painted weathering effects give a real sense of life to any object. Note the paint chips on the nose cone of this craft.

Imply Imperfections

Imply small imperfections in your work, even when working to a very high-detail standard. For example, a slightly jiggled and imperfect reflection adds a measure of realism to the windows in this image. A pure reflection might be mathematically sounder, but it would not look nearly as interesting.

Strong Composition Is Key

Do lots of quick studies before starting a highly detailed piece like this one so that you don't invest too much time into a piece that is flawed compositionally. A cornerstone of interesting art is great composition and framing—get that right first, then you can paint away! The image here is tranquil, yet still very much alive thanks to wonderful composition and framing.

Balance Photos With High-End Paintwork

When working at a high level of clarity, you will likely be heading towards a photo-realistic final look, or you might want to incorporate photos into your work, such as in matte paintings. The best possible outcome in any photographic and painted final piece is an overall united feeling. Achieving this can be a complicated process. The key is to mesh any incoming resources with the painted areas so they all work together. Follow along to see how a photograph of a car can work within a fully painted background.

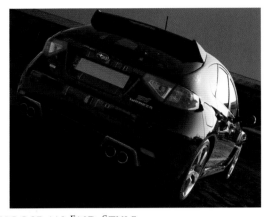

1 CHOOSE AN END STYLE
Decide what style you are aiming for with the final piece so that you know which direction you're heading with your creative process. Once you've established your end style, prepare to bring the photo into the scene. Here is a basic image of a car, which will be cut away from its parking-lot background.

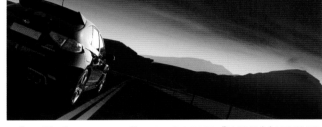

2 SET UP LIGHTING BALANCE AND BASIC MATTING
Drop the photo into the scene and work with two layers: the painted background and the overlaid photo. Make some adjustments to bring simple continuity to both layers. To make them similar in tone and color, execute a quick color pass using the Brightness and Contrast and, most importantly, Color Balance modes to gently tint the paintwork and glass with the ambient colors in the scene. This is imperative as both surfaces are reflective.

In this image, a bit of work was done to remove the old car's reflections and the bodywork was pared back so new reflections can be added to represent the newly painted background.

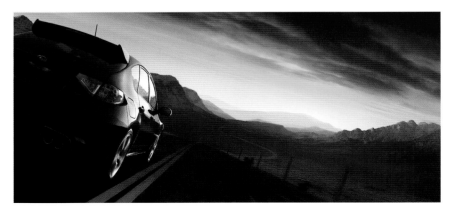

3 BRING IT ALL TOGETHER
Be careful, methodical and respect the original photo. Paint the environment so it looks enough like a photograph to have the car in it, but not so amazing that it detracts from the focal point. Transform the car from a 100 percent photograph to a stylized version of a photographic-quality vehicle. Note the careful reflections in the car, and the balance of the secondary parts of the composition, such as the mountain range on the horizon.

Movement Adds to Detailed Images

Even finished high-detail images can be transformed by adding a bit of movement to the scene. Not every image needs to have explosions and fast-moving race cars, but there are ways to give the viewer something new to look at and to improve depth and composition.

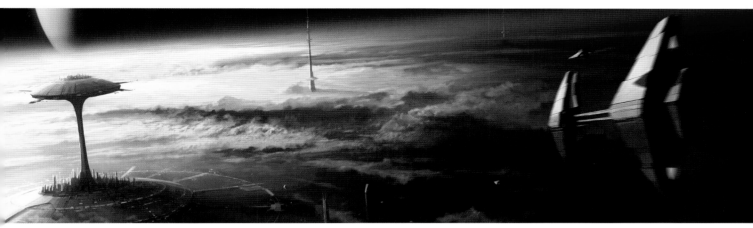

Original Image
The finished painting had a beautiful tranquil feeling, but there was also an opportunity to add balance to the large space station at the right of the piece.

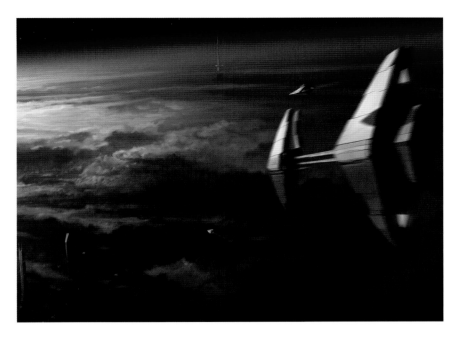

Image Altered With Addition of Moving Objects
I set up a new layer, painted a large craft and port, and then added a simple radial blur to give it a sense of movement. The altered image is not necessarily better than the original, but with the addition of the craft heading for port after a long journey, it does tell a different story.

Index

ABOUT THE AUTHOR

Gary Tonge is one of the UK's foremost concept designers, with over 20 years experience as a digital artist. He currently works at Swordfish Studios as Art Director for electronic games, where he is responsible for the look and feel of gaming products as well as pushing artistic styles and concepts for the company. Recent products he has project managed include 50 Cent: Blood in the Sand and Operation Flashpoint: 2 and 3. He also has a successful freelance business, VisionAfar, whose client base is as diverse as his art and includes the BBC, Vivendi, Capcom, Eidos, Sims Snowboards and National Geographic. He is a regular contributor to *Imagine FX* magazine and recently launched a new website, www.visionafar.com. He lives in Coventry, UK.

Other fine IMPACT books are available from your favorite bookstore, art supply store or online supplier. Visit our website at fwmedia.com.

15 14 13 12 11 5 4 3 2 1

Adobe product screenshots reprinted with permission from Adobe Systems Incorporated. Adobe® and Photoshop® are either registered trademarks or trademarks of Adobe Systems Incorporated in the United States and/or other countries.

DISTRIBUTED IN CANADA BY FRASER DIRECT
100 Armstrong Avenue
Georgetown, ON, Canada L7G 5S4
Tel: (905) 877-4411

DISTRIBUTED IN THE U.K. AND EUROPE
BY F&W MEDIA INTERNATIONAL LTD
Brunel House, Forde Close, Newton Abbot, TQ12 4PU, UK
Tel: (+44) 1626 323200, Fax: (+44) 1626 323319
Email: enquiries@fwmedia.com

DISTRIBUTED IN AUSTRALIA BY CAPRICORN LINK
P.O. Box 704, S. Windsor NSW, 2756 Australia
Tel: (02) 4577-3555

Edited by Christina Richards
Designed by Guy Kelly
Production coordinated by Mark Griffin

Metric Conversion Chart

To convert	to	multiply by
Inches	Centimeters	2.54
Centimeters	Inches	0.4
Feet	Centimeters	30.5
Centimeters	Feet	0.03
Yards	Meters	0.9
Meters	Yards	1.1

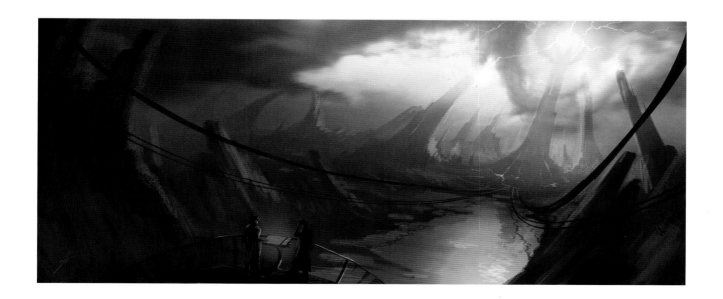

ACKNOWLEDGMENTS

I would like to thank everybody who has taken time to read this book and all those who have read *Bold Visions* and sent me messages of support and thanks.

There are many people in my life who mean a lot to me. I have a wonderful family and a lot of fabulous friends who offer me support, humor, insight, perspective and love whenever I need it. I have listed these people below in no particular order and hopefully I have not missed any

My beautiful, wonderful and supportive wife, Michelle you make me want to always be a better man, my wonderful daughters, Catherine, Jessica and Ella. My Mum who I miss dearly, see you soon, my Dad for working to be a better man, my brother Craig, his wife Vikki and their two boys Jacob and Lewis, Anne and Tim, James Bonsor, Kevin and Michelle, Kerry and Neil, Mark and Tracy, Daisy and Lily Rose, Michael and Pauline, Martin and Danielle, Lisa, Paul and Reese, Rich and Shell, Chris and Dawn, David Percival, Joe Flores-Watson, Paul and Ruth, Andy Speirs, Matt and Cheryl, Chris and Zoe, Mark and Donna, Adam Karran, Gail Karran ,Stuart Blythe, Julie and Nick, Jane and Alan, Andy Norman, Michel Bowes (freedom!!), Mike and Judy, James Farnhill, Carl Entwistle, Kevin Crossely, Philip Straub, Fergus Duggen, Susanne Sexton, 533 Diversey Parkway, Paula Thompson, Anne Garner, Mo Siegel, Jay Peregrine, Christilyn Biek Larson, Seema Chopra, Neil and Marie, Martin and Becks, Les and Dot, Maggie and Reg, Graham Gallagher, Darren and Sarah, Ady and Sonia, Roberto Cirrilo, Liam Kemp, Greg Martin, Dave (where is he?) Pate, Mark Donald, Andrew Wright, Alex McLean, John McCambridge, Gerard Miley, John Haywood, Herod Gianni, Wayne Dalton, Steve Wakeman, Stuart Williams, Darren Yeomans, Joel Beardshaw, Colin Nicholls Siddhartha Barnhoorn, Paul Vodi, Christian Hecker, "MMM", Tigran Aivazian, Saskia Raevouri, B.E Johnson, Joy Day, Simon Reed, John Haywood, Christian Russell, Matt Charlesworth, Trevor Williams, John Payne, Phil Chapman, Rich Morton, Daryl Clewlow, Gavin Rummery, Alan Sawdon, Joe Stone, Roger Mitchell, Carl Tilley, Dan Scott, Allison Bond, Jerry Oldrieve, Andy Gibson, Freya Dangerfield, Ame Verso, John Howe, Craig Mullins, Syd Mead, Iain Mccaig, Ryan Church, Aly Fell, Stephan Martinere, Eric Tiemens. And to every striving, struggling and stratospheric artist out there— have faith! Finally and most profoundly to God for all that I am and all that we all can be.